THE
ENCYCLOPEDIA
OF
PRINTMAKING
TECHNIQUES

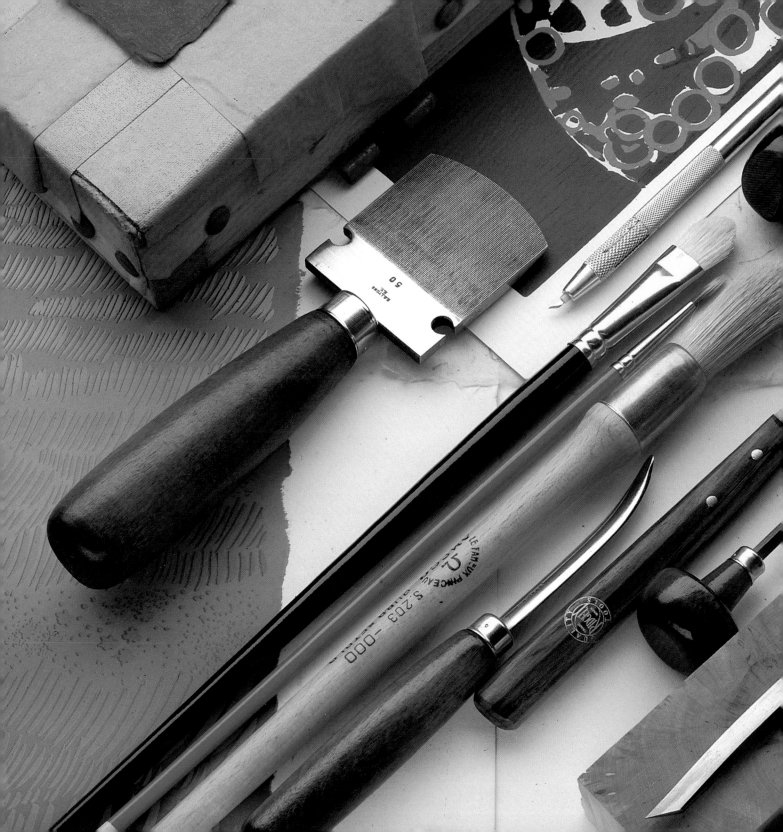

THE
ENCYCLOPEDIA
OF
PRINTMAKING
TECHNIQUES

JUDY MARTIN

SEARCH PRESS

A QUARTO BOOK

This edition published in 2014 by
Search Press Ltd
Wellwood
North Farm Road
Tunbridge Wells
Kent TN2 3DR

First published in Great Britain in 2001 by
Search Press Ltd

ISBN: 978-1-78221-127-3

This book was conceived, designed and produced by
Quarto Publishing plc
The Old Brewery
6 Blundell Street
London N7 9BH

QUAR.EPM

Senior editor: Kate Kirby
Editor: Hazel Harrison
Senior art editor: Amanda Bakhtiar
Designer: Nick Clark
Photographers: Duncan Phillips, Chas Wilder, Les Weis
Picture researcher: Liz Eddison
Art director: Moira Clinch
Publishing director: Janet Slingsby

Printed in China by Toppan Leefung Printing Limited

The author would like to thank the artists who have
contributed work to this book, particularly the
members of North Star Studios, Brighton, who
provided technical demonstrations. Special thanks
also to Kate Kirby for efficient and good-humoured
editorial support on this and previous projects.

Publisher's Note

Working with printmaking chemicals demands care, as
some you will be using are poisonous and/or corrosive.
This means you must take precautions: always follow
the manufacturer's instructions; always store chemicals
securely in clearly-marked, non-food containers, and
keep them well out of the reach of children. As far as
the techniques used to apply the chemicals and the
effects they produce are concerned, all statements,
information and advice given here are believed to be
true and accurate. However, netiher the author,
copyright holder or publisher can accept any legal
liability for errors or omissions.

INTRODUCTION

Printmaking covers an impressively wide range of activities and pictorial matter – there is something for everyone here. But printmaking studios, with their strange, alchemical combinations of unfamiliar materials, purpose-made tools and monumental machinery, can seem like alien territory, even to experienced artists quite comfortable with other kinds of studio practice.

However, there is no need to be daunted by the technicalities, because many of the printmaking processes are very straightforward and easy to grasp. Some, such as lithography and etching, are inherently more complex, but they can be learned in stages so that the newcomer can gradually build confidence and grow in ambition. In fact the necessity to follow specific technical procedures provides a framework for the creative side of image-making that many artists regard as a supportive element. As you become immersed in practicalities, the process itself suggests ways of interpreting your image.

This book is an invaluable introduction to printmaking methods, taking you step by step through the technical details as well as providing inspirational examples of prints in all media. Although

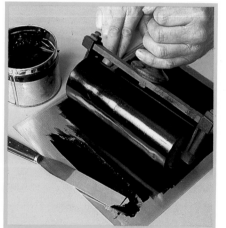

some of the print processes have a long tradition and are carried out in much the same ways as they always were, there can be no doubt that modern technology has made it easier to extend the potential of individual printmaking methods and to combine their effects in multi-media images.

Well-known professional artists who produce "edition" prints often have much of the processing carried out for them by equally professional print technicians, but in this book the priority is to relate the techniques and inspirational images to things you can easily achieve yourself with readily available equipment and facilities. Although it is necessary to have access to a properly equipped studio and presses in order to develop the full potential of most techniques, there are methods you can carry out from start to finish working on your kitchen or living-room table. Keep this in mind as you look through the book and choose the printmaking areas you might like to work with. Once you have understood the principles and mastered some basic techniques, you can bring your own inventiveness and creativity into play to adapt the chosen methods to suit your style of work and situation.

Contents

TECHNIQUES

❁

THE STEP-BY-STEP DEMONSTRATIONS IN THIS SECTION OF THE BOOK ARE THE IDEAL INTRODUCTION TO THE RANGE OF PRINTMAKING METHODS. THE SEQUENCES ARE DESIGNED TO PROVIDE A CLEAR EXPLANATION OF WHAT THE MATERIALS, TOOLS AND EQUIPMENT CAN DO IN EACH CASE, AND WHY CERTAIN PROCEDURES ARE NECESSARY. ONCE YOU BEGIN TO WORK WITH YOUR CHOSEN METHOD YOU WILL SOON ACQUIRE THE PRACTICAL KNOWLEDGE THAT ENABLES YOU TO THINK CREATIVELY IN TERMS OF PRINTMAKING ITSELF.

PRINTMAKING METHODS

There are two main reasons for choosing to produce an original image as a print, one being to obtain a number of identical copies. The motive for this may be to originate pictures as multiple images or to reinterpret an existing painting or drawing in print form. Because prints sell more cheaply than one-off originals they are accessible to people who do not normally invest in art, and can thus represent a useful share of an artist's income. For the amateur, there is a considerable pleasure in having works on paper that can be sold cheaply or given to friends, while one or more can be retained by the artist.

The second reason for making prints is that each process produces characteristic visual qualities quite different from those of a directly drawn or painted image. For example, the flat, glossy colour areas you see in a linocut or silkscreen print cannot easily be obtained with paint and brush; and the grainy, integrated textures of chalk drawing and ink washes produced by lithography are distinctly different in feeling to similar marks applied directly on paper. Etching is a law unto itself: an etched line is not at all like a drawn line, and there are many ways of achieving etched textures that give an exciting variety to this long-established medium.

The way the image is produced influences not only the character of the finished work but the way you conceive and plan it. Before you start to consider which processes would suit you best, take account of the following basic principles.

Basic principles
The methods of producing a printed image can be divided into four main categories: relief printing, intaglio, planographic (printing from a flat surface) as in lithography, and stencil processes as applied in screenprinting. In the relief-printing techniques of linocut, woodcut and wood engraving (pages 36–53), the original flat surface of the wood or lino block represents the printing surface. Any parts of the design not to be printed are cut away, leaving the image raised in relief. This is inked, usually with a roller, and transferred to paper by direct pressure.

Intaglio processes – drypoint, mezzotint and etching – are the exact opposite. All these are usually done on metal plates, and the design is incised or etched into the surface. It is the sunken lines and areas of the plate that are printed, by pushing ink into them and applying heavy pressure to press the paper into the inked marks; the original surface level of an intaglio plate represents the white in a black and white image.

Lithography is a planographic process, meaning that the printing and non-printing areas are on the same level. The image is drawn on a metal plate (or litho stone) and processed so that it "sets" into the grain of the surface. Lithographic prints can be taken by direct pressure or by offsetting. On an offset press, plate and paper are placed side by side; a roller travels over the plate and picks up the inked image; travelling back, it deposits the image on the paper.

Screenprinting is basically a stencilling process. The screen

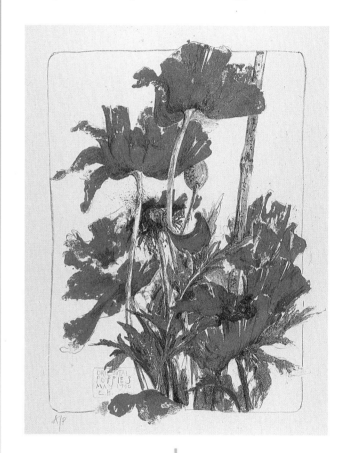

Elisabeth Harden
Oriental Poppies (lithograph)
In lithography, the artist's drawing and painting skills are directly applied to developing the image on the plate, using inks and crayons. This can result in a very vivid, spontaneous feel to the finished print, although the build-up of colours has to be carefully planned, with each individual hue printed from a separate plate, and mixed colours achieved by overprinting. The marks made by the drawing materials supply the varied surface qualities of the image, but the grain of the litho plate also influences texture.

has a stretched, fine mesh which transmits an even layer of ink under pressure. To create the image, parts of the mesh must be blocked so they cannot allow the ink through. There are many different ways of preparing stencils, all of which produce characteristically different qualities in the imagery.

Negative and positive

A printed image taken by direct pressure is always reversed on the paper because the original block or plate is in face to face contact with it. Relief and intaglio processes both produce reversed images, as does lithographic printing on a direct-pressure press. In offset lithography, the image is not reversed, because it is put down on the paper in the same position as it was picked up from the plate – an intermediary surface carries the inked image, and there is no direct contact between plate and paper. In screenprinting, too, the image is right-reading, because the ink passes through the screen mesh rather than

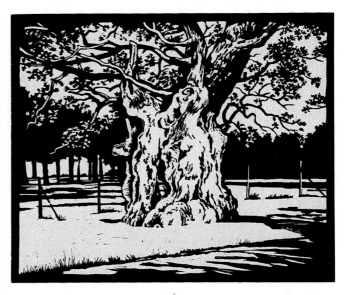

Jonathan Heale
Tree (woodcut)
The relief printing technique of woodcut and linocut produces strong, highly graphic effects, which show most clearly in a powerful monochrome image like this. The stark black-and-white contrast requires the artist to select essential details from the subject and organize a balance of tones.

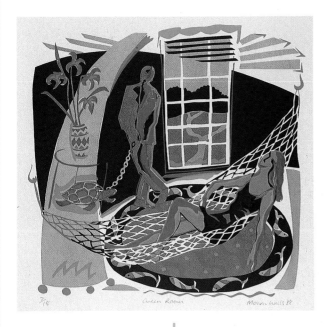

Moira Wills
Green Room (screenprint)
Bold shapes and clear colours are frequently the hallmark of screenprints made from hand-cut stencils, although there are many ways to vary the qualities of surface texture. Here the artist uses a lot of lively pattern detail to keep the eye moving around the image.

Screenprinting inks provide a wide range of colours that have great brilliance and luminosity, but can be mixed or overprinted to produce deep, rich tones and muted hues.

being printed off from it.

This left-to-right reversal is not the only "opposite" element you have to keep in mind when preparing images for printing. Often you are required to work in negative – that is, the marks you make with your printmaking tools represent the non-printing areas of the design. In relief prints, the parts of the block that you actively cut away surround the parts that will read as the image. In screenprinting, where you are preparing a stencil to print, for example, blue areas of the image, the stencil itself will consist of all those areas that will not be blue. Conversely, in lithography and most intaglio processes, the marks you make are those that directly create the image.

These concepts can seem confusing when put into words; they start to make sense as you come to deal with them in practice. There are also exceptions to the rules – resist techniques for preparing a screen image, for example, and one or two specific etching techniques, when you do invert the normal procedures. For this reason you need to start simply with any printmaking method, learning the basics that give you the ability to think through the processing in logical steps. As you gain in experience and confidence, you can discover the variations that enable you to exploit the properties of your medium more fully and apply them to an expressive rendering of your subject.

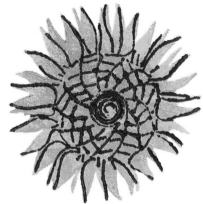

Collage print

Colour and texture

Prints of the same subject carried out in the full range of media show some of the characteristic differences between printmaking processes and their effects. Monoprints and collage prints are technically quite simple to make, but can provide a wide range of painterly qualities. The intaglio methods of drypoint and mezzotint are primarily tonal, but differently approached – drypoint by drawing positively in black line and tone, mezzotint by burnishing whites out of dark texture. Similarly, wood engraving typically appears as white lines on black, while the other relief methods – woodcut and linocut – more often rely on black key-line images, although both are easily adapted to colour printing. Etching, lithography and screenprinting each incorporate a variety of techniques enabling equally varied, simple or sophisticated surface effects.

Etching

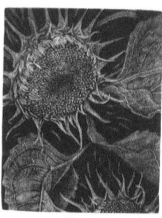

Mezzotint

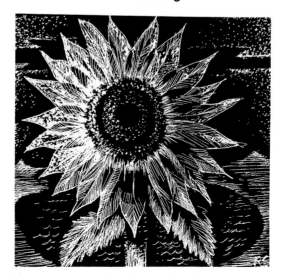

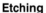

Wood engraving

Monoprint

Woodcut

Drypoint

Linocut

Lithography

Screenprint

THE WORK ENVIRONMENT

There is no doubt that the ideal situation for learning and practising all the major printmaking processes is a properly equipped print studio. For most non-professional artists, the easiest and least expensive way to achieve this goal is to join organized classes in printmaking at a local art school or adult-education institute. For the more ambitious who would like to devote some regular time to specific processes, it may be possible to hire time in a professional studio or join a co-operative of artists sharing printmaking facilities.

However, having no access, or very limited access, to a studio by no means disqualifies you from producing interesting prints. Monoprints, linocuts, woodcuts, wood engravings and collage prints can all be prepared and printed at home. The main advantage of using a print studio is access to a printing press, which enables you to produce reliable, good-quality impressions quite quickly. But you can produce finished prints from flat surfaces and blocks by a simple hand-printing method. Alternatively, you can prepare printing blocks at home and take hand-printed proofs, then arrange to use a print studio only for the time you need to refine the design and take your final prints on the press.

Printing presses

There are various printing presses, some dedicated to one printing method, others adaptable to more than one. A relief-printing press typically relies on direct pressure. In flat-bed presses such as the Albion and Columbian types, the block is placed on the bed of the press and an upper surface is brought down to exert heavy pressure on paper and block. An alternative is the old-style type-proofing press, formerly used by typesetters. This kind of press has a sunken bed in which a thick wood or wood-mounted lino block can be set. A cylinder with the paper attached is rolled across the block under pressure.

Intaglio printing is done on a roller press, a flat, heavy metal bed suspended between two rollers. The space between the rollers is adjusted to vary the pressure as required; the metal intaglio plate with paper laid on top is positioned on the bed, and the bed is passed between the rollers. This press can be adapted to relief printing provided that the original block is not too thick to be accommodated by the rollers. A relief-printing press, however, cannot normally be used for intaglio because it does not exert sufficient pressure to force the paper down into the sunken areas of the plate.

For offset lithography, a specialized press is required. This has a long bed on which the paper and plate are positioned side by side. A very

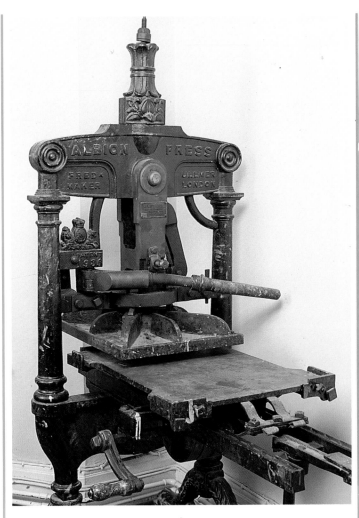

large, heavy roller occupying the whole width of the bed trundles along its entire length, moved either by a handle or an electrically powered mechanism. The rubber "blanket" around the roller picks up ink from the plate as it passes forward, then puts it down on the paper as it moves back.

Large printing presses are cumbersome, heavy and extremely expensive. Even if you could find an affordable secondhand one you might

Using a flat-bed press
1 The upright section of the press supports a heavy platen that moves downwards when the bar is pulled across. The flat bed is rolled out from underneath to position block and paper, then taken back underneath before pressure is applied.

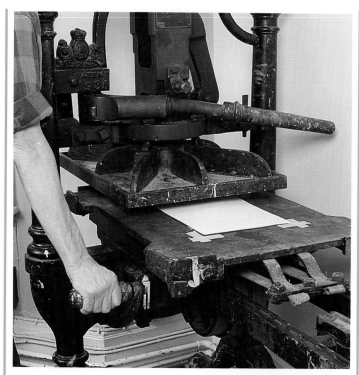

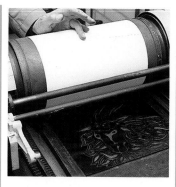

Proofing press
This kind of press was originally designed for printing type blocks to produce galley proofs of texts. The bed of the press accommodates the height of the type blocks, so is ideal for printing woodcut blocks and wood-mounted lino. The paper is fitted to the cylinder, which is then rolled over the inked block.

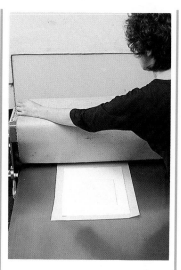

Etching press
A press for printing intaglio plates, which are only a few millimetres thick. When a geared handle is turned, a flat metal bed passes between two weighty metal rollers. To soften and spread the pressure, blankets are used to cushion the action of the rollers.

2 The handle is turned the other way to take the bed right back underneath the platen, to position the block centrally so that even pressure will be applied.

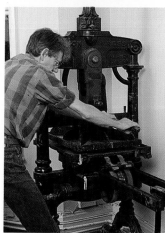

3 With the bed in position, the artist grasps the bar and pulls it towards him, which lowers the platen onto the bed. This takes some effort, as the downward pressure activated by the movement of the bar is powerful.

need to have the floor of your workroom strengthened before the press could be installed. New roller-press models are more compact and lightweight. The capital outlay is considerable, but you will have a machine that will see service for years. On a smaller scale, table-top versions of the intaglio roller press are available at reasonable prices.

Screenprinting facilities
You can easily set up a small-scale screenprinting operation at home, since the basic equipment is self-contained, relatively lightweight and can be constructed to a required size. You must have a perfectly flat surface for printing, so it is

best to hinge the screen to a permanent printing bed or baseboard so it can be raised and lowered freely. Screens can be bought ready made from some art and craft retailers, or you can make your own – there are several specialist publications that explain this in full detail.

If you are working in a print studio, you may be using a metal printing frame attached to a vacuum bed. The frame is adjustable so that the screen can be securely locked into it. The printing bed has a network of small holes across its full length and width. When the mechanism that creates the vacuum is switched on during printing, it creates suction

Metal drying racks
The metal frames form a stack, each frame hinged at the back so it can be lifted easily to slip in prints on lower layers. This kind of drying rack is highly suitable for relief prints, screenprints and lithographs.

Ceiling racks
1 These purpose-made wooden racks have slots containing a ball-and-wire mechanism that grips the top edge of the print and allows the paper to hang straight.

2 To insert the print, the ball is pushed upwards and the paper slipped in against the wire. When the ball drops back, its own weight secures the paper. The same action releases the print.

keep sharp cutting tools away from other equipment vulnerable to damage, such as soft gelatin rollers.

One important space that it is easy to overlook is an area where prints can be left to dry. You may wish to print twenty or thirty impressions at one time, in which case you will have a lot of pieces of paper that have to be stored separately for up to two days – and left somewhere where they can dry flat with no risk of sticking together. A simple solution is a "washing-line" system of cords strung above eye level, on which prints can be hung using bulldog clips or similar fastenings. If you have a plan chest, which is useful storage for clean paper and drawings or paintings as well, you can lay out the prints for drying as the top layer of each drawer. Or you can construct a wood or metal shelving system with shallow openings so that the prints can be leafed in to lie flat on the shelves.

Studio drying systems include wooden ceiling-hung racks with ball-and-wire attachments that grip the top edge of the prints, and metal-frame stacks that flap up and down so you can insert the prints to lie flat on a wire grid in several layers. Intaglio prints, which are taken on damp paper, are usually pressed between boards while drying, so that the paper does not buckle. The prints are leaved between blotting or tissue paper to prevent them coming in contact with each other.

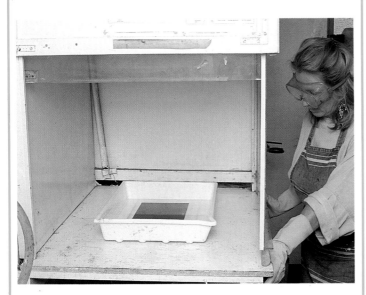

Safety features
The acid bath in an etching studio is one of the most obviously hazardous work areas, which needs special facilities. This one sits below a ventilator hood, and can be completely enclosed by drawing down the plastic sides of the boxed-in area. The artist takes the precaution of using goggles and rubber gloves when working with the acid.

from below that holds the paper down on the flat surface.

Work areas
The other advantage of a properly set-up studio is that there is an allotted space for each stage of the work. This helps to keep the work clean and the tools and equipment in good condition. Also, different chemicals can be stored separately to avoid accident.

If you are working at home on relief prints or screenprinting, there are a few basic guidelines to take into account. For simple, practical reasons, it is helpful to have separate areas for preparation and printing, because this allows you to work on both at one session without taking time to clear up and reorganize. For example, cutting blocks or preparing a screen stencil could be done in one area and printing off from them in another. You can also

Safety
Safety factors are particularly important in both etching and lithography. Various stages of

etching involve working on the metal plates with heat, acid or flammable substances, while chemical preparations are used in lithography, and the flexible metal plates and mechanical press need careful management. However, under proper guidance, both processes are quite safe. Any chemical that gives off fumes must be used in an area with good ventilation, and goggles, a face mask and rubber gloves are necessary precautions when you are dealing with acid or other caustic liquids.

Generally, however, your alertness to the safety angle should be much the same as when you are cooking or carrying out home repairs. Don't leave things to "cook" on a hotplate; don't let sharp tools lie about exposed or jumble up different types of equipment; immediately clean up liquids or inks that spill on the floor so that you don't slip.

PRODUCING PRINTS

Getting from the picture in your mind's eye to the finished print on paper is not just a matter of technical skill, but also of working with the medium appropriately at each stage of processing. This includes the way you initially conceive and prepare your image for print form. For the beginner, this is a chicken-and-egg situation – if you don't know what the process can do, how can you plan the final image? On the other hand, if you haven't begun with a definite visual idea, what are you to work on in order to learn how to print?

To find out what the particular marks and materials you apply will turn into when processed and printed, you can start off by working direct on a block, plate or screen in a purely abstract manner. A test plate or block is not an unusual first step. You probably won't achieve a finished image with much form to it in this way but you may find you have produced a useful reference chart for future use.

Working drawings

More commonly, you will start with some reference work – a sketch, drawing, painting or photograph – as the basis for the print. The first thing to realize is that any form of printmaking is an interpretive, not a reproductive method. In other words, the print will not look exactly like the original. The working drawing is a guideline to composition, visual qualities such as the relationship of line work and solid colour areas, and the overall scheme of colour. These elements have to be translated into the new medium and cannot be copied exactly, although in all media you can trace and transfer an image as your starting point – it is not necessary to redraw the composition from scratch.

For the inexperienced printmaker interested in producing prints in two or more colours, the working drawing is an essential step. You have to make a separate block, screen or plate for each

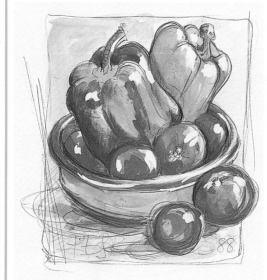

From drawing to print
1 The composition of the still life is worked out in a detailed pencil and watercolour sketch. The artist needs to establish the overall shapes clearly and plot the colour and tonal variations within them. These are to be translated into a three-colour print – yellow, red, green – in which mixed hues will be achieved by overprinting.

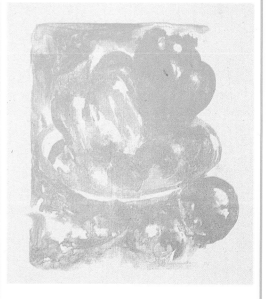

2 Yellow is the dominant colour, contributing to each aspect of the still life, so it covers a broad area of the first printing plate. However, it will not have this full-strength effect in the final print. Being light-toned, it will recede somewhat against the other colours.

main colour, and work out whether you can overprint colours to produce mixed hues. Sometimes, once you have isolated the areas for printing one colour, you will find that an originally realistic image is reduced to a series of more or less abstract shapes, and you cannot relate this to the other colours without some initial guideline. It may be best to make a fairly detailed working drawing and trace off each colour element with some accuracy. As you learn more of your craft, you can cut down the detail of this preliminary stage and simplify your plan to the bare essentials. Experienced printmakers may start straight in without doing this at all because they feel confident of working direct with the print medium and can anticipate how the stages will gradually pull together.

Proofing and printing

In order to understand how the image is translating into print, proofs are taken at various stages. These working proofs also act as guidelines for further stages, such as the continued cutting of a block or processing of a plate; until you have seen the image as it prints you will not know where to develop it further or where to make corrections and adjustments.

On a relief block, you can take a rubbing rather than a printed proof, which is less laborious and gives you a fair idea of the image quality. An etching can be proofed at any stage, but on a mezzotint or drypoint plate the printing areas are relatively fragile – too many proofs cause the surface to deteriorate – so what you gain from proofing you may lose in the final printing.

When you are ready to take the final prints you can run a whole edition. An edition is a numbered set of identical prints – in commercial terms, the numbering is a safeguard of their value, and professional artists' plates or blocks are cancelled after an edition has been completed. The artist chooses the number of prints in an edition; sometimes it may depend on how the printing surface stands up to wear, as with drypoint and mezzotint. An artist's proof is a finished print that does not form part of the edition set – the first few trials of the final printing may become artist's proofs if the quality is good.

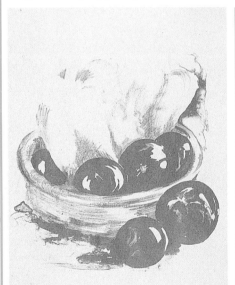

3 The red obviously has to be strongest in the tomatoes, and will print lightly over the yellow on the bowl in order to produce a warm orange. In the peppers, it is used tonally rather than as a distinct colour, to create the subtle shadows that model the forms.

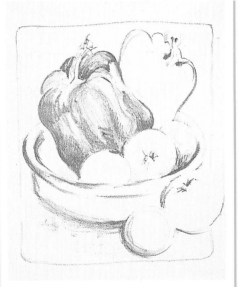

4 The green printing has a more linear character, defining the contours of the forms quite strongly. As with the red, the colour has two functions, providing local colour in the green pepper and enhancing the detail and modelling of the red and yellow fruits.

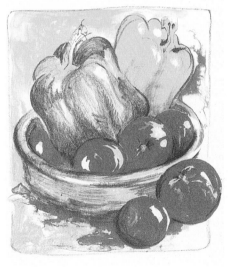

Elisabeth Harden
Peppers and Tomatoes
(lithograph)
The print is less heavily modelled than the original, since it contains no black that would correspond to the pencil drawing. The bright colours have a lush, fresh feeling appropriate to the subject. Dark shadows emerge from the overprinting of all three colours.

Inks and papers

The work done with the printmaking materials is not the only factor in the finished qualities of the print; the way you ink up the image and the paper you print on contribute other surface values. At the later stages of preparing any kind of print, your proof stages should ideally use the same inking procedure and type of paper you intend for the finished version, as only then can you see the true effect.

Obviously different methods of printing require different properties from ink and paper, and proprietary-brand inks, available from specialist suppliers, are purpose-made for each one. Block-printing inks are more widely sold, and can be bought in most good art shops. In some cases – notably relief printing and screenprinting – you may find a choice between water-based or oil-based inks. Typically, oil-based types give the smoothest coverage and the most versatile effects, but the prints take longer to dry, and blocks or screens have to be cleaned up with the appropriate solvent. If in doubt, explain to the supplier what you intend to do and get advice on the right type and texture of ink and colour ranges available for your kind of work. If you are studio-based, the supervising technician or tutor will advise.

Most relief and screen prints can be made on almost any kind of paper – even on fabric – but the weight, thickness and finish of the paper affects the appearance of the final image. Again, you may need to get advice on exactly what is needed in your case, but the following are some basic guidelines:

● For early proofing of block prints, screens and lithographs, inexpensive newsprint or cartridge paper are quite adequate. Good-quality cartridge papers are also suitable for final proofs. Use a fairly substantial kind, as very thin papers may buckle under the ink.

● For processes which involve dampening the paper, mainly the intaglio processes, do not use anything too flimsy or open-textured, such as unsized papers which may disintegrate when wetted. However, papers that are too thick and stiff will not penetrate the intaglio and will pick up a broken impression. The best papers for intaglio are good-quality drawing and watercolour papers, which come in a variety of weights, thicknesses and surface textures.

● Avoid extremes of surface texture – on exceptionally smooth, coated papers, ink can slide or smudge easily. You might, for example, get a double impression if the paper slips on a relief block during printing. Equally, be wary of very thick, heavily toothed papers, which may resist the ink.

● If you are interested in using decoratively coloured or textured papers, bear in mind that they will contribute specific qualities to the finished print which may not integrate appropriately. However, lightly toned non-white papers – ivory or cream – and fibrous, lightweight Japanese papers are popular with printmakers. Strong base colours can be planned in as a specific element of an image; you can print white ink onto a coloured surface if required.

Papers

Different kinds of papers have practical purposes in printmaking, as well as providing the base material for the finished print. In intaglio printing, blotting and tissue papers (top, upper layers) are needed to prepare and store the dampened printing paper; prints can be taken on a variety of surfaces, including fine hand-made or good-quality mould-made drawing and watercolour papers (above). Textured and coloured papers (right) are useful for collage work and relief printing. To develop a printed image from an existing drawing or working study, you will also need tracing and transfer papers (below).

MONOPRINTS

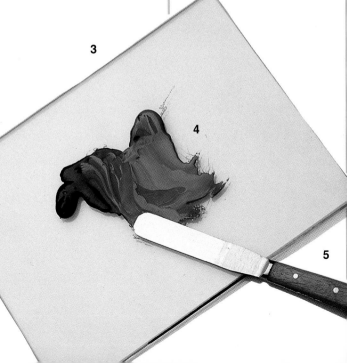

A monoprint, as its name implies, is a one-off impression made by applying printing ink to a flat surface and transferring it to paper. The method excludes one of the usual main purposes of printmaking, which is to obtain multiple copies of a single image, but the marks and textures obtained are characteristically different from those drawn or painted directly on paper. Monoprint is of particular interest to beginners in printmaking, because no presses or special studio equipment are needed.

Tools and materials

The printing surface can be anything which is flat, smooth and non-absorbent. Suitable materials are a sheet of glass,

image is printed in reverse, as with relief printing methods.

Developing the print

Monoprints can be graphic monochrome studies or vigorous multi-coloured images. You can also overprint; for example, to build up thin colour "glazes", develop dark tones or lay in line work over solid colour areas. You do this by taking your first print, then cleaning off the working surface and reworking with ink to take a second impression.

To overprint accurately, you need to use a simple form of registration. You can simply align the paper to the edges of the surface you are printing from, or if this is not large enough to give a good margin of paper around the printed image you can lay a larger registration sheet beneath, visible on at least two sides, and align the printing paper to that. In the demonstration sequence shown here, the artist places a working sketch beneath the sheet of glass as a guide for each painting stage and for registration of overprintings.

Although you cannot produce a series of prints by re-inking, as you can with a etched plate or incised block, you can sometimes obtain two or three impressions from one inking; they will become gradually fainter, coarser-textured and less colourful. There are various ways you can experiment with this medium, apart from the way you prepare the initial design. Variations in thickness of the ink and the pressure you apply to the back of the paper will affect both the tone and texture of the print.

Monoprint equipment
1 Brushes; 2 papers; 3 glass mixing slab; 4 block-printing inks; 5 palette knife; 6 roller.

plastic or metal; a slab of polished stone, or a section of plastic-faced wood or composition board. To create your image, you can apply block-printing inks (or oil paints) using any suitable implements – brushes, rollers, sticks, rags, sponges or palette knives – to build up the design, just as though you were drawing or painting on paper. Then you simply lay a sheet of paper over it and rub firmly but evenly across the back of the paper. When you lift it, the

6

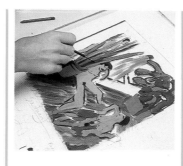

Printing from glass
1 This method of preparing a monoprint image involves painting on the surface of the glass slab as you would on paper. The artist is using printing inks, and has placed a rough sketch underneath the glass as a guide.

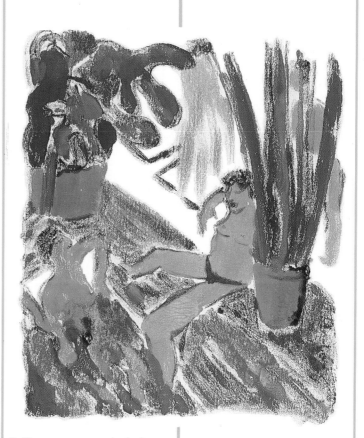

2 The print is taken by laying paper on the glass and smoothing it down with your hand, a spoon or roller. This produces a typically softer, more textured impression than in the original painting.

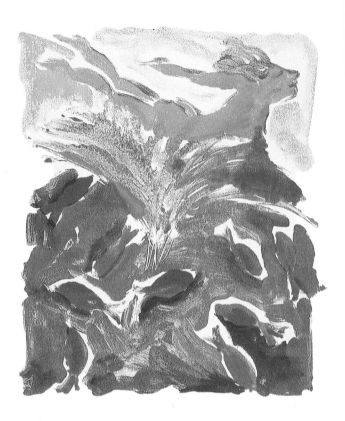

2 By dragging and lifting the ink with a rag dampened with white spirit, she draws free, broad shapes in the colour area.

3 The paper is placed over the glass sheet, aligned to the left-hand edge of the working drawing below the glass, and the print is taken by hand-rubbing. This gives a soft, moody monochrome image.

Printing from acetate
If you work on acetate sheet rather than glass, you can take the print on a press rather than by hand. The additional pressure makes the colours stronger and the textures more detailed.

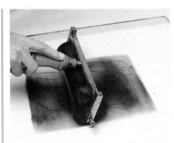

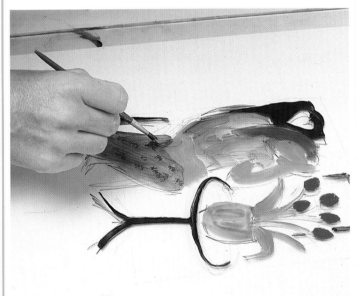

Overprinting
1 For the first stage of a three-stage print, the artist rolls out a flat layer of thin ink on glass. A sketch guide is positioned underneath the glass.

4 The second stage is prepared by painting on the glass with several colours. The underlying sketch is the guide for positioning the colours so they will overprint accurately on the monochrome image.

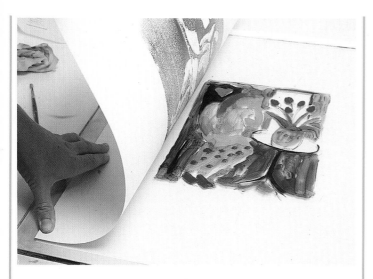

5 The monochrome print is aligned to the left-hand edge of the paper beneath the glass and laid down over the painting, which is again printed off by hand-rubbing on the back of the paper.

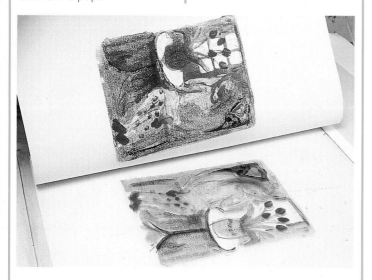

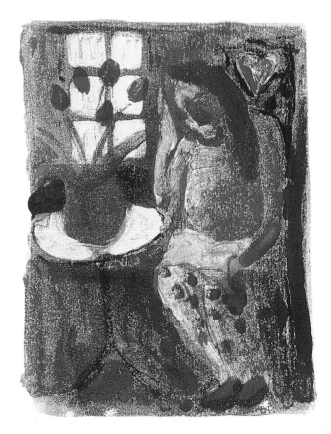

6 The artist partially removes the painting by cleaning it off with white spirit on a rag. She then reworks the dark toned areas with fresh ink and takes a third impression.

7 In the finished print, the overprinting has produced a variety of tones and textures that create a simply stated but highly atmospheric image.

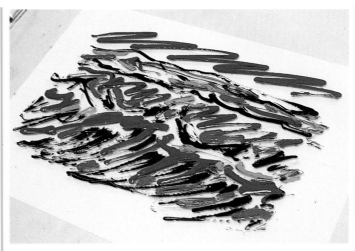

Linear drawing
1 Block-printing ink is rolled out thinly on the glass slab. The colour areas are roughly estimated in relation to the subject to be drawn.

2 A sheet of paper is laid down over the ink, and the wooden end of a paintbrush is used to draw on the back of the paper. Alternatively you can use a pencil, knitting needle or other suitable implement.

Developing textures
1 This experimental sequence investigates patterns and textures relating to water and wave patterns. Coloured inks are squeezed onto the glass directly from the tube.

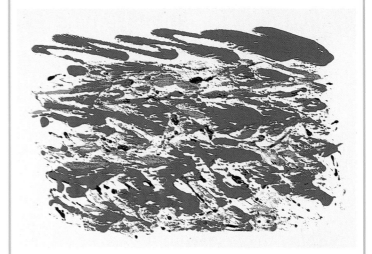

3 The impression shows a soft but strong line quality that gives an expressive character to the drawing. The background is lightly textured through contact with the rolled-out colours.

2 A simple blotting off onto paper spreads the ink marks and produces a vigorously textured surface. There is always a random element to these very basic printing techniques.

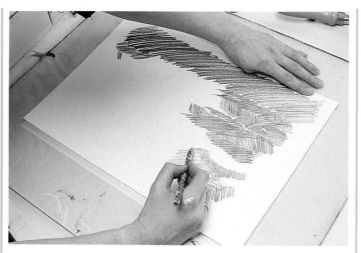

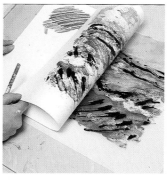

3 The artist works into the painting on glass by blotting the colours again and adding fresh ink. The top band of the colour layers is rolled out to create a feeling of the division between sea and sky.

4 Paper is placed over the ink, and using a pencil the artist begins to draw roughly scribbled wave patterns, working the hatched textures in different directions.

5 Progress can be checked at any stage by peeling back the paper; keep one edge in place so that the paper goes back in exactly the same position. If the image is not strong enough, the pressure of the pencil marks can be varied or reworked.

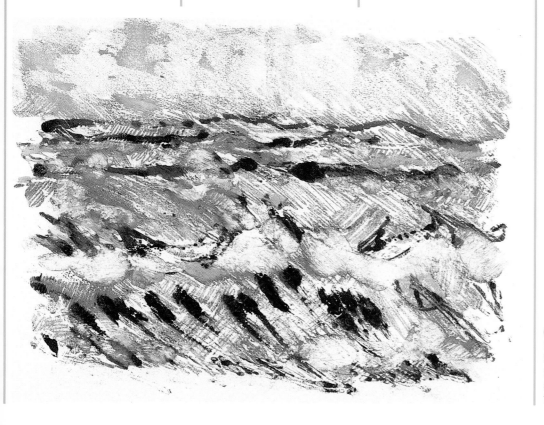

6 This impression has a looser, busier texture than the simple blotted-off image in step 2. The movements of the pencil create a more active surface in the finished print.

LINOCUT

PLANNING THE IMAGE

CUTTING THE BLOCK

PROOFING AND PRINTING

COLOUR PRINTING

This is an excellent printmaking technique for the complete beginner. The process of preparing the block is relatively simple, and after only a little experiment with the tools you can quickly produce a strikingly original image, either monochrome or multi-coloured. A printing press is not essential, so you can satisfactorily complete the whole process without access to specialized studio facilities.

Lino is a sympathetic medium in that it is relatively soft and easy to cut, but because of its pliability, it is not suitable for very fine line work, which can break down in the course of cutting or printing. Monochrome linocuts make use of the material's strong graphic potential, exploiting bold shapes and patterns. Printing in two or three colours allows many possibilities for texturing and shading the image.

Tools and materials

Lino is a corky, composite sheet material with a hessian backing. You can obtain small pre-cut lino blocks from most art-material shops, and large pieces or rolls up to 1 metre (3ft) wide from specialist suppliers of printmaking materials.

The quality of lino varies; sometimes the block is very smooth and compact, but the texture can also be grainy and liable to crumble when cut. It deteriorates with age, becoming hard and brittle. Warming the block before you start cutting helps to soften a "difficult" texture, easing the passage of the tools. Lino has a naturally oily feel, but the surface can be de-greased before you start work by wiping with methylated spirits or rubbing gently with a fine-grade sandpaper.

The principal lino-cutting tools are gouges and V-tools of different sizes. You can also use an ordinary craft knife to cut grooves in the block or to outline areas to be cleared with the gouges. Blunt tools can easily tear the soft lino, so they should be kept sharp.

The block is inked with a roller. Different sizes and types are available, made of rubber, gelatin or plastic. Inexpensive rollers are often too hard to give even coverage; a softer roller is more sensitive to any variations in the lino surface.

Linocut equipment

1, 2 Palette knife and push knife, for mixing inks; **3** tap knife for cutting lino; **4** spoon for hand-printing; **5** roller; **6** lino; **7** gouges; **8** V-tools; **9** baren, a purpose-made tool for hand-printing.

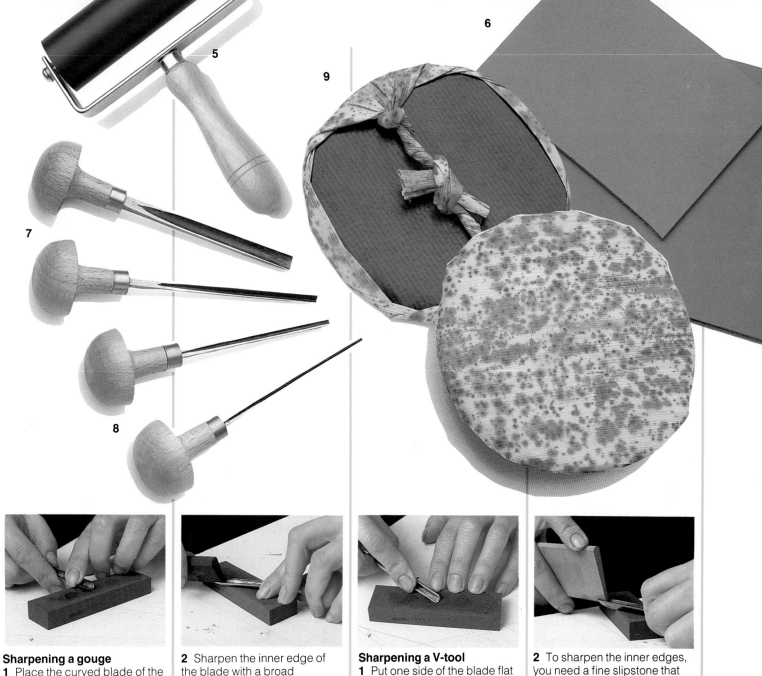

Sharpening a gouge

1 Place the curved blade of the gouge on an oilstone and rock it from side to side so the whole edge makes contact with the stone.

2 Sharpen the inner edge of the blade with a broad slipstone. Support the tool firmly while rubbing the stone back and forth.

Sharpening a V-tool

1 Put one side of the blade flat on the oilstone and rub it back and forth. Repeat with the other side to sharpen both outer facets and the point between them.

2 To sharpen the inner edges, you need a fine slipstone that fits into the "V". Support the shaft of the tool as for the gouge, while moving the stone inside the blade.

PLANNING
THE IMAGE

You can mark out your design in pencil, marker or Indian ink applied with brush or pen, de-greasing the surface first if necessary. If you are using a working drawing, you can trace this down on the block using transfer paper. Remember, however, that the image will appear reversed when printed; if you want it to read the same way round as the original, reverse the tracing before you transfer it to the block.

Alternatively, you can make the original drawing directly on the block, as shown here. If you make errors, you can either draw over them, remembering to ignore the incorrect lines when you begin to cut, or you can wipe out the error with a suitable solvent and rework the area completely.

Any shape in a linocut design can be cut positively or negatively: that is, you can cut around the outline of the shape or you can remove the whole area within the outline. When working in monochrome, you need to plan the interaction of lines and shapes carefully, working out what to do with the edges where two or more shapes butt together, and how to vary and contrast areas of plain colour and pattern.

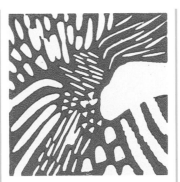

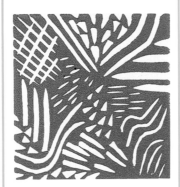

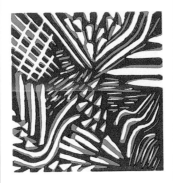

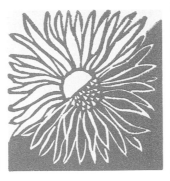

Gouge marks
The gouge makes a bold stroke that can be clean-edged or lightly toothed. This sample shows long and short cuts with (from left to right) medium-sized, fine and broad gouges. The rough-edged mark is made by easing the tool from side to side, as well as forward through the lino.

V-tool marks
This sample shows a comparable range of marks made with medium-sized, fine and broad V-tools. The beginning of the cut is slightly tapered where the "V" bites into the lino. You can end the cut with a taper by easing the tool up gradually, or you can form a squared end by stopping the stroke abruptly.

Developing texture
A more complex textured effect can be obtained by quite simple means when you are overprinting colours. This shows where the same marks of the V-tool have been recut more broadly for the black printing.

Line and tone
The tools can be used to cut the main shape in outline or to cut away the surrounding areas, leaving the outline in relief. You may even wish to combine the two approaches in one design and should plan how you will make the transition between solid shapes and line work.

Drawing on the block
1 For this demonstration of cutting a monochrome image, the artist works directly from the subject, drawing on the block with a black waxy pencil.

2 The markings on the fish form the most intricate part of the design and they are drawn in some detail. The shape of the plate has been drawn to position the whole design on the centre of the block.

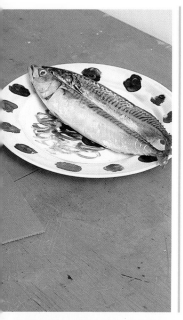

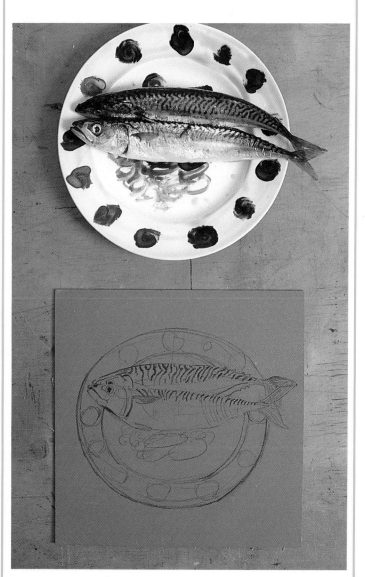

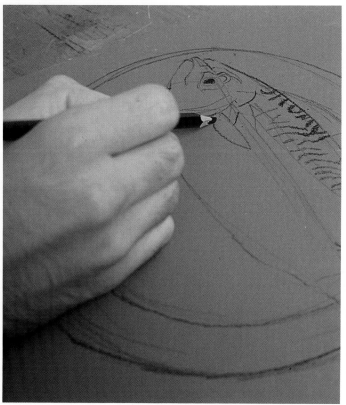

3 The pattern on the plate is indicated very loosely, leaving the artist an open choice as to how to treat those areas as the cutting of the design develops.

CUTTING
THE BLOCK

There is no particular order or sequence to cutting into the design. For example, you can begin with narrow cuts outlining the overall shapes, then work into detail and clear any large "white" areas; or you can work from one side to another, completing each section as you go. You will soon learn to judge which tools provide the right width of cut and how much pressure you need to apply. Avoid working too heavily, as it is easy to slip and cut into a section that should be left uncut. Move the tool easily and evenly; if you angle a knife or V-tool blade too sharply, you may undercut the lino, which makes lines and edges unstable.

If you have a large area to clear which is "non-reading" in the print, or you are shaping the outer edges of the block, you need not do all the work with the gouges. You can cut away the surplus lino with a craft knife or scissors.

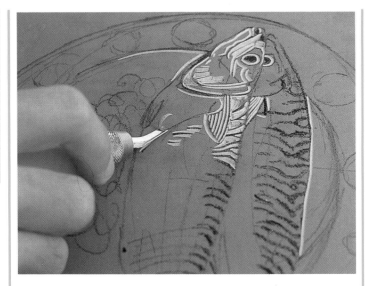

Cutting the block
1 Initially a V-tool is used to establish fine outlines and work into the detail of the fish head and body.

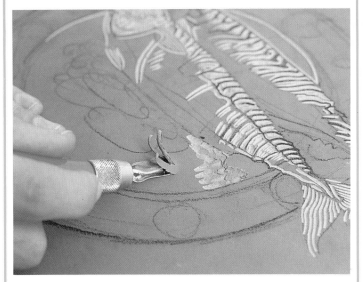

2 Once the markings of both fishes have been described with careful line work, the artist begins to clear the "white" areas, working rapidly with a broad gouge.

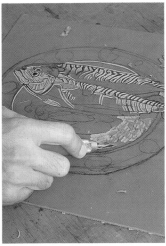

3 The gouge is used roughly so that the lowered surface of the block retains some relief texture that will print.

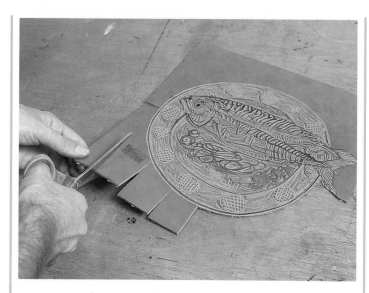

4 The outer border around the design is not to print at all. Rather than clear it with a gouge, the artist cuts the lino away. The shape of the plate is outlined with a V-tool, then cuts are made from the edge towards the outline.

PROOFING AND PRINTING

For a monochrome print like the example shown here, you can check the progress of the cutting without actually rolling up and printing the block. Simply place a piece of paper over the surface and take a rubbing with a pencil. This will be accurate enough to show you where further cutting is required, and whether there is a good balance of negative and positive areas.

When the block is ready to print, roll out the ink thinly on the inking slab, then roll it over the raised areas of the lino firmly and evenly. You can work back and forth in all directions, and if you put down too much ink you can take up some of the excess by running the roller in one direction only.

You can take a print either by placing paper over the block and rubbing with a baren, a spoon or any other suitable smooth, curved tool; or you can print on a flat-bed, cylinder or proofing press.

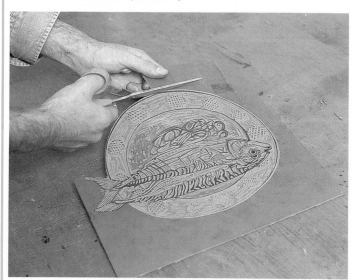

5 The edge-cuts make the lino more flexible, allowing the scissors to ease accurately around the circular shape. If the border area were cut with a gouge, some residual marks might appear on the print, but removing the surplus ensures a clean outline.

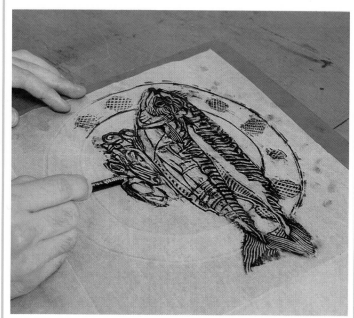

Proofing and printing
1 Rather than ink the block to pull a proof, the artist takes a rubbing on thin paper with a graphite pencil. Any refinements needed can be cleanly cut before printing.

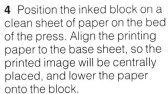

4 Position the inked block on a clean sheet of paper on the bed of the press. Align the printing paper to the base sheet, so the printed image will be centrally placed, and lower the paper onto the block.

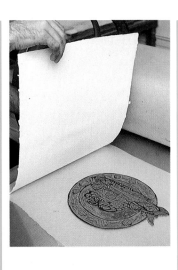

2 When the design is complete, it can be inked and printed. To roll ink out evenly, spread it across the glass slab with a palette knife, then work outwards with the roller until the ink forms a thin coating.

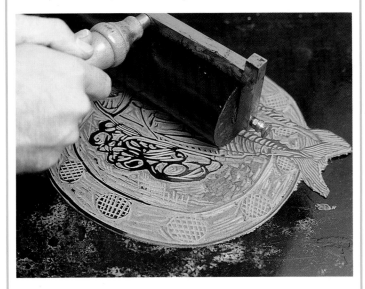

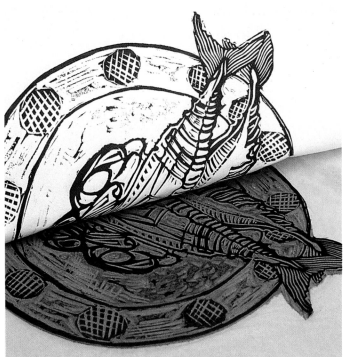

3 You can work in all directions when rolling up the block. Go over it as many times as you need to coat it evenly with colour, picking up more ink on the roller as necessary.

5 Activate the press to exert even pressure on the block and paper. Take hold of one corner of the printing paper and peel it back gently from the block.

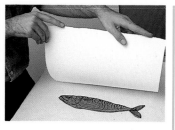

Printing without a press
1 If you have no access to a press, you can use this hand-printing method, also known as burnishing. Ink the block and position it on a clean base sheet. Lay the printing paper over it.

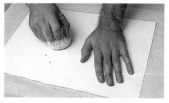

2 Use a rounded implement such as a purpose-made baren, the back of a spoon or, as here, an etching dabber wrapped in muslin, to rub firmly and evenly all over the back of the printing sheet.

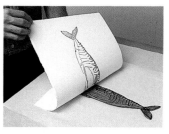

3 A print taken by this method is naturally lighter coloured than one taken on a press, because the pressure is less intense. As you continue to take prints and the ink layer on the block builds up, the image becomes darker and more even.

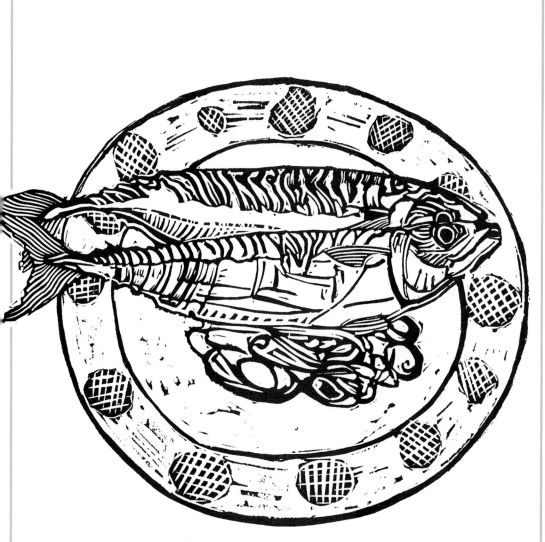

6 The completed print has a bold, graphic style, with crisp black line work nicely offset by the incidental patches of rough texture in the whites. Variations in the line widths give a pleasing "hand-done" quality without detracting from the clarity of the image.

33

COLOUR PRINTING

Multi-coloured linocuts can be prepared by one of two methods. In the reduction process, successive cuts are made in the same block, and a new colour is printed at various stages. The other method is to register the design on separate blocks, one for each colour. The reduction method* (demonstrated under woodcut printing), may be easier to register for printing, as it is the same block you are using at each stage; but the block is gradually destroyed by the continuing work, so you have to be confident about how much of the surface is to be removed for each printing.

Using two or more blocks gives you more time to think through the cutting stages, and you can proof all the colours to compare and amend the different areas. However, any slight variations in the dimensions or shape of the blocks' outer edges can make it difficult to align each printing.

To cut two or more blocks, you can use a master tracing to place the image on each, but a more accurate method is to cut the first block and use it as the key block for offsetting the image onto the uncut lino pieces. As shown here, the method used to register block and paper for the offsetting is then also used to register the overprintings.

FURTHER INFORMATION

*Woodcuts: colour printing, page 40–45

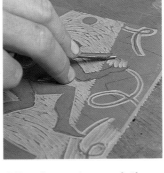

Offsetting and overprinting
1 Cut your block for the first colour, using the appropriate marks and textures for the effect you wish to achieve.

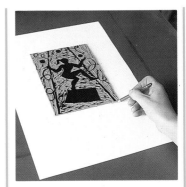

2 Ink up the first block in black and lay it centred on a clean sheet of paper on the bed of the press. With a pencil, mark the edges and corners of the block on the base sheet. This sheet will form your guide for registering subsequent printings. Take a print from the block on smooth paper.

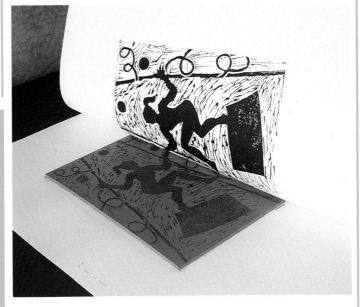

3 Lay the uncut second block in the marked area on the base sheet and place the black print over it, aligned to the edges of the base sheet. Run this through the press so that the print transfers colour onto the clean lino block.

Registering on the press
This method of registration is a simple alternative to the use of a base sheet, as shown in the main sequence. Mark the positions for the block and printing paper directly on the bed of the press, using small strips of card attached with masking tape. Butt the corner of the block to the inner cards. Next slip the corner of the paper in to align with the outer registration stops before lowering the full sheet over the block.

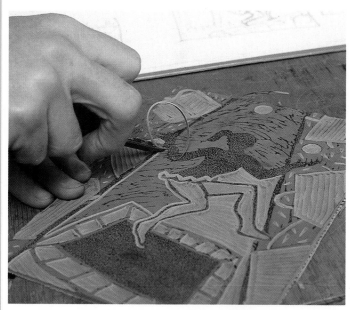

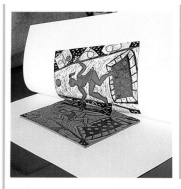

7 Roll up the second block in the required colour – in this example it is to print black over red. Position the block on the base sheet, register the printed image over it and run them through the press.

4 Use the shapes offset from the first block as a guide to cutting your design for the second colour. Pay special attention to areas where the two colours will overprint, and any shapes that must register exactly.

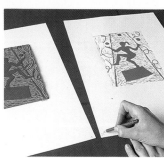

5 Roll up and print the first block in the required colour. Here it is printed in red: this is the same block that was printed black in steps 2 and 3 to offset the image.

6 You may find it helpful to mark one corner of the base sheet and the corresponding corner of the print with a small cross: each time you come to print, from a second or subsequent block, match the crosses and then align from that corner. This is particularly valuable when you are printing several colours, as the prints can appear quite abstract in the early stages and it is easy to make an error in overprinting.

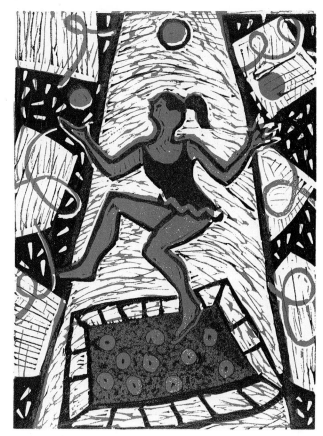

8 This extremely lively image combines solid blocks of colour with roughly worked gouged textures and bold patterns made with the V-tool. The registration of colours on the figure is deliberately inexact to add to the sense of movement, but where required, background shapes have overprinted cleanly along the same outlines.

WOODCUT

CUTTING THE BLOCK

COLOUR PRINTING

Woodcut printing is very similar in technique and process to linocut, but different in style and surface quality due to the properties of the base material. Woodcuts are made on the side grain of the wood, and the natural pattern and direction of the grain are integrated with the textures and patterns made by the cutting process.

In linocutting, the tools cut easily in all directions, but for woodcuts it is easier to cut along or with the grain than across or against it. The type of wood used – how heavily grained and hard or soft it is – will also affect the print. You can obtain interesting variations between clean and ragged edges, sharp knife cuts or broadly gouged channels. Woodcuts are associated with the aggressive, jagged graphics of European Expressionists, but also with the clarity and formality of Japanese colour prints, so a wide range of variations is possible.

Tools and materials

A useful aspect of the woodcut process for beginners is that you can use almost any type of wood. Instead of buying specially prepared blocks you can pick up offcuts of plyboard or timber from a woodyard. Pine boards and plywood sheets, inexpensive and readily available, are highly suitable for trying out the cutting techniques and gaining confidence with the medium. They are relatively coarse and liable to splinter, but are also soft to cut and have pleasing, pronounced grain patterns. As you become interested in the process of woodcut and practised in the techniques, you can investigate finer, denser woods that allow more delicate control. The only way to discover and exploit the characteristics of different types is to try them.

Tools for woodcut include the V-tools and gouges also used for linocut. The interchangeable gouge sets, however, are unsuitable as they are not strong enough; use the metal-shafted individual gouges. Cutting knives are extensively used in woodcut; specialist tools are available from printmaking suppliers or you can use a sturdy craft knife. Chisels are also useful tools for abrading the surface and clearing large areas.

Prints are made from wood blocks in exactly the same way as from lino: the surface is inked and the print can be taken by hand or on a press. Thin plyboard can be printed on a cylinder or flat-bed press. A thick wood block must be printed by the direct pressure of a flat-bed press, or on a type-proofing press where the block can be packed into a sunken bed and the paper rolled over it.

Woodcut equipment

1 Side-grain wood blocks; **2** gouges and V-tools; **3** craft knife; **4** cutting knife, for fine-line work on block; **5, 6** push knife and palette knife; **7** block-printing ink.

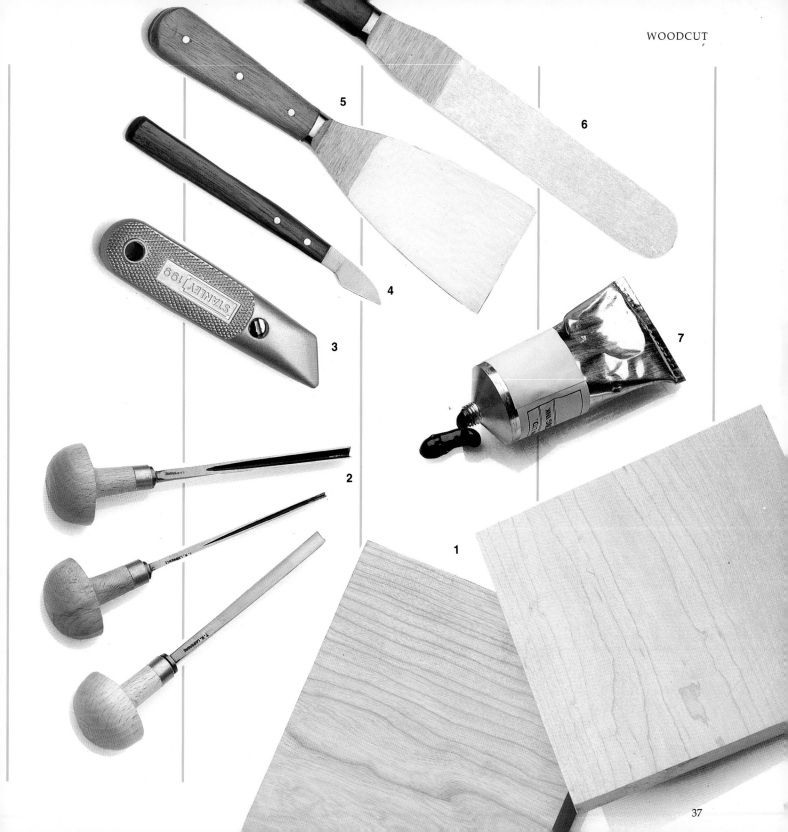

5

6

4

3

7

2

1

CUTTING THE BLOCK

Some artists cut directly into the block without preparation. Others may prepare the surface by sandpapering or brushing with a wire brush to remove any loose fibres and bring up the grain pattern. As with lino, you can draw onto the surface with pencils, markers or brush and ink, or trace down a design using transfer paper. You can if you wish stain the surface all over by rubbing it with diluted printing ink; this enables you to see the cut marks very clearly as you progress.

Wood is quite a responsive surface, and you can obtain good effects from a variety of different marks. Try to get the feel of the tool as you cut, particularly as you change its angle to the grain. Pushing a gouge easily along the grain produces even, clean-edged cuts, but cutting too boldly across it can cause major splintering that strips too much of the surface.

The width of the gouge you choose has to be matched to the elements of your design, but otherwise the choice of tool is a matter of common sense – there is obviously more labour involved in trying to clear a large area with a narrow gouge than with a wide one. In an open area, you may leave small ridges that will print as a broken texture; this can be effective, but if after proofing you find it is not suitable you can clean up the shape and remove any cutting marks.

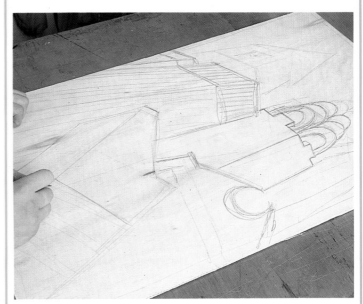

Cutting the block
1 Unless your design is small-scale, or you are very confident in cutting, it is best to draw a fairly detailed outline of the image on the wood block.

Using gouges
1 All woodcut tools cut most easily along the grain of the wood. A small gouge makes clean-edged fine lines suitable for outlining or hatched textures.

2 The print shows how the grain of the wood contributes a specific background texture, where the relief surface is allowed to print as large areas of dark tone.

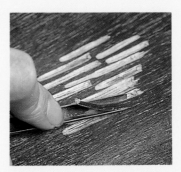

3 Broad gouges are used for line work. In addition, by keeping the cuts very close together or overlapping them, broad gouges can be used to clear areas of the block.

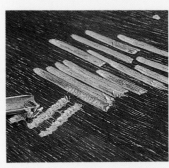

4 Pushing the gouge across rather than along the grain, you encounter more resistance and may need to ease the gouge from side to side as it moves forward.

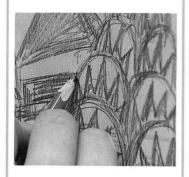

2 In this example the image depends upon some intricate pattern-making in the structures of the buildings. The artist draws this in detail, filling in lines and shapes that feature strongly.

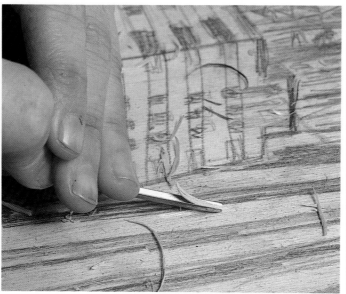

3 She begins cutting the broadest lines, stripping the wood rapidly with a gouge. As with lino, there is no particular rule as to where you should start.

4 Because the print will consist of a four-colour sequence, the cutting at this stage is relatively limited, consisting only of those elements that will appear white in the final print. Fine detail is worked with a narrow gouge.

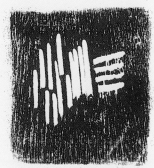

5 Although the width of the tool mark does not vary much, you can see how working along or across the grain produces different edge qualities.

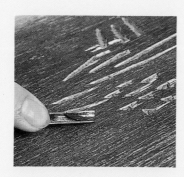

6 The V-tool reacts similarly to the gouge in terms of the direction it takes. However, if the angled blade is sharp, the cross-grain resistance may be less influential because the cutting edge is less broad.

7 A V-tool cut begins sharply and broadens as the full width of the blade bites into the wood Short, angular cuts produce interesting coarse textures.

8 The actual character of each mark may be less important than the way the tools are used to cut particular elements in the design, but this sample block demonstrates a wide range of textures obtained with only three tools.

COLOUR PRINTING

This demonstration shows a four-colour wood block cut and printed by the reduction method. In the first cutting, only the areas to remain white are taken out, and the block is printed with the first colour rolled all over the surface. In the second stage, the areas to remain as the first colour – in this case a light-toned buff – are removed, and the whole block is printed in yellow. In the third stage, areas to remain yellow are cut out and the block is printed in blue. Finally the blue areas are cut away and the remaining relief surface is overprinted in black.

With the reduction method it is not necessary to follow the process of offsetting demonstrated for linocut, but you can use the same registration process to ensure that the colours overprint accurately. In this case, however, having printed the first colour, the artist registers the block for each subsequent printing by laying it face down on the print rather than aligning the paper over the block. For this you need a confident eye and steady hands.

Printing and overprinting

1 When the first stage of cutting is complete, you can immediately print the first colour (you may wish to take one proof first to check the balance of the image and the effectiveness of individual shapes). Roll up the whole block with an even layer of ink.

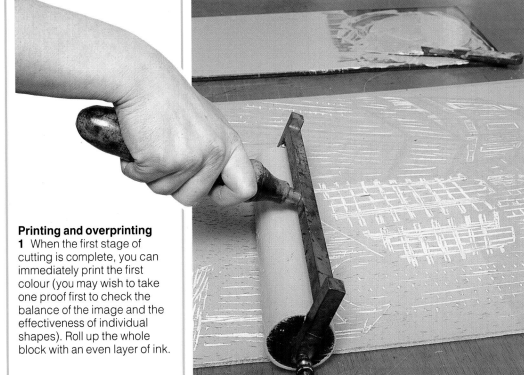

2 Run the print through the press and peel back the paper carefully. Once you have begun to lift the paper, it is advisable not to lay it back down, as any slight shift can create a double image.

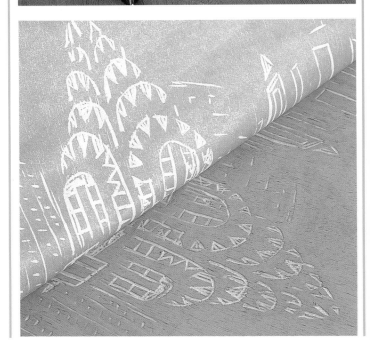

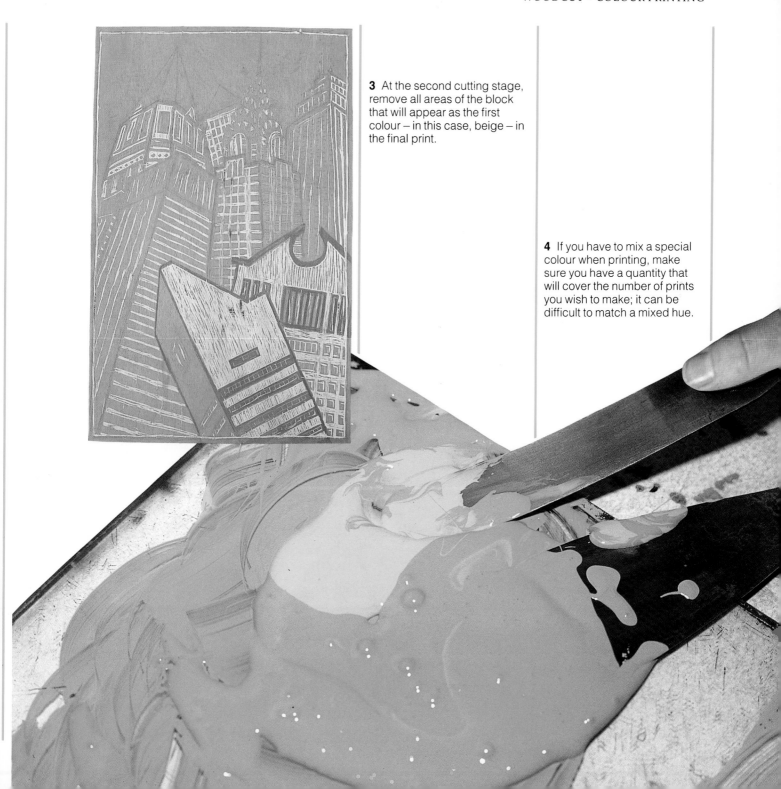

3 At the second cutting stage, remove all areas of the block that will appear as the first colour – in this case, beige – in the final print.

4 If you have to mix a special colour when printing, make sure you have a quantity that will cover the number of prints you wish to make; it can be difficult to match a mixed hue.

5 Roll up the block in the second colour, working in all directions to produce an even coating of ink. It is advisable to have a roller that relates well to the size of the block. A large brayer is being used here.

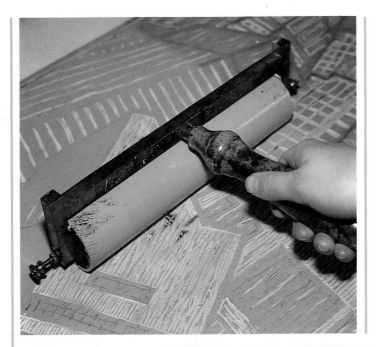

6 To register the second colour over the first, the artist lays the block face down on the original print, judging the alignment of edges and corners by eye.

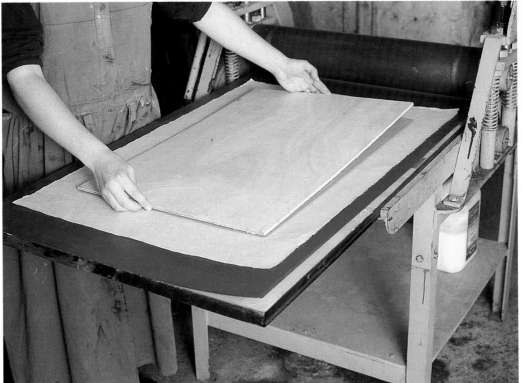

7 The cutting in the third stage consists of removing all the areas of the image that should appear yellow in the final print. An experienced artist may work directly on the block; for a beginner, it is helpful to use a previously prepared colour study as a guide.

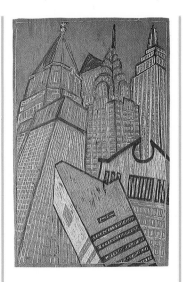

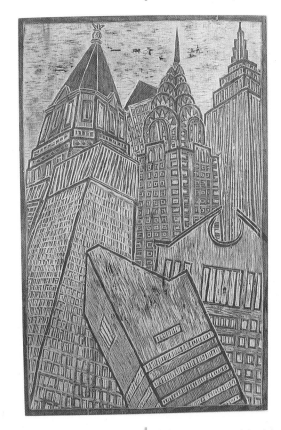

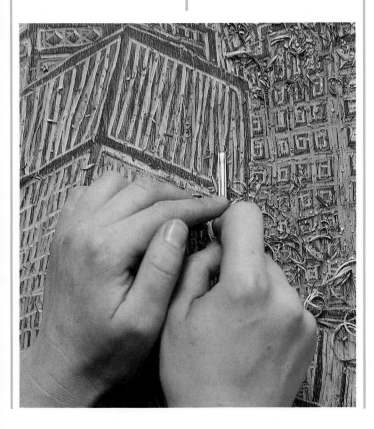

There may be a lot of detailed cutting at the final stage, because in order to allow the previous three colours to show through, much of the remaining relief surface becomes linear in character.

9 Large areas of the block have now been cleared, particularly the sky, which is very open. The cutting is deliberately rough, so that a lightly textured impression will show up between the more emphatic lines.

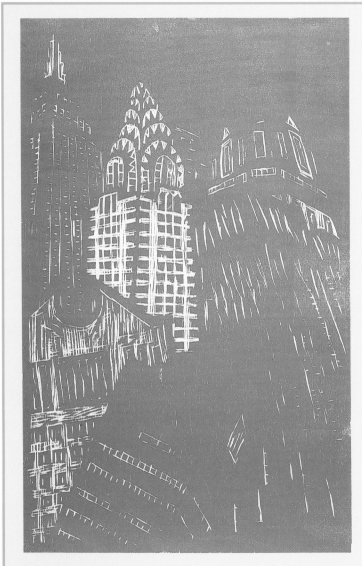

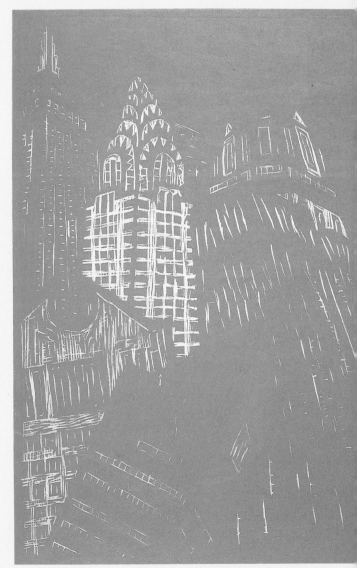

Stage proof: two
The second colour printing begins to suggest the three-dimensional depth in the image, but because the two colours are close in tone, the change is not dramatic.

Stage proof: one
In a print made by the reduction method, the first colour printing may include a lot of broad, flat colour areas where the detail will be created by the cutting for subsequent colours. When printing is completed, clean the ink from the block immediately with solvent and a rag.

Stage proof: three
The overprinting in blue, using the same registration technique as for the yellow, produces a more appreciable variation in the image, both because the colour is lighter than those underneath and because the textures are becoming more complex.

Stage proof: four
The black printing sharpens the image and gives it a much bolder, more graphic feeling, pulling together all the shapes. This is the effect that the artist has been carrying in her mind throughout the cutting processes. The radical changes that occur with each successive stage are a very exciting feature of colour printing. Although with experience you can anticipate many aspects of the colour interactions, the overall result can still contain surprising and unexpectedly pleasing details.

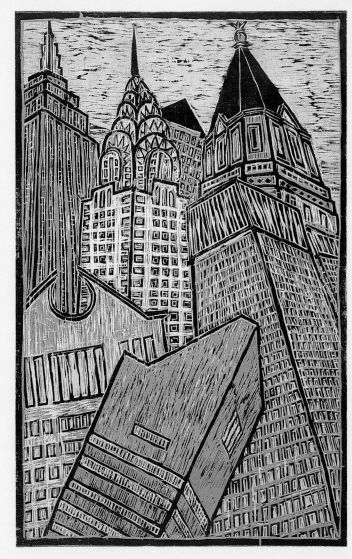

WOOD ENGRAVING

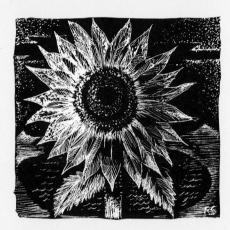

CUTTING THE BLOCK

PROOFING AND PRINTING

Wood engraving is a much finer, more delicate process than woodcut. The cutting is done on the end-grain of the wood, which has a very tight texture. The grain is not a feature of the design – the image is created entirely by the cut marks.

The techniques of wood engraving are controlled and precise, but you can achieve a wide variety of marks and textures. For practical reasons wood engravings are usually small-scale, and it is easier to produce an image that reads as white lines on black than to clear areas of the block leaving black lines in relief. It is typically a monochrome method (although the relief surface can be inked in any colour) since the engraved work is too detailed and tight to allow the processes of re-cutting and overprinting that can be exploited with side-grain wood and lino. Printing in black, or a very dark-toned colour, best conveys the subtle graphic effects of the engraving.

Tools and materials

The preferred wood for end-grain blocks is box, which has a tight grain but is relatively soft and easy to engrave. This is a slow-growing, small tree, so wood-engraving blocks are usually only 5–8cm (2–3in) across – larger blocks are made by jointing small pieces together. They are expensive, but you do need to obtain the blocks from a specialist supplier, as the wood must be properly seasoned and prepared. Holly, pear or maple, cheaper substitutes, may also be available. In addition compact blocks of plywood or manufactured board can be used.

The engraving tools are fine shafts of metal faceted and sharpened to form various shapes of cutting tip. The main types are the lozenge-shaped graver for general line work, the elliptical spitsticker, designed for cutting curves; the squared or rounded scorper, used for broad marks and clearing areas of the block; and the fine tint tool, which

1

maintains a line of uniform width. It is important to keep the tools sharp, as blunt tools slip and slide on the close-grained surface.

To cut curves and angles you turn the block rather than the tool. To facilitate the movement it can be mounted on the traditional engraver's sandbag, but you can work just as effectively by resting the block on a book wrapped in a cloth. Raising the block also helps you to grip it and hold it steady.

The block-printing ink for wood engraving should be quite stiff, or it may flood the delicate marks. A small gelatin or rubber roller is adequate for inking the little wood blocks. Prints can be taken easily by hand-burnishing, using a spoon or baren to rub the back of the paper.

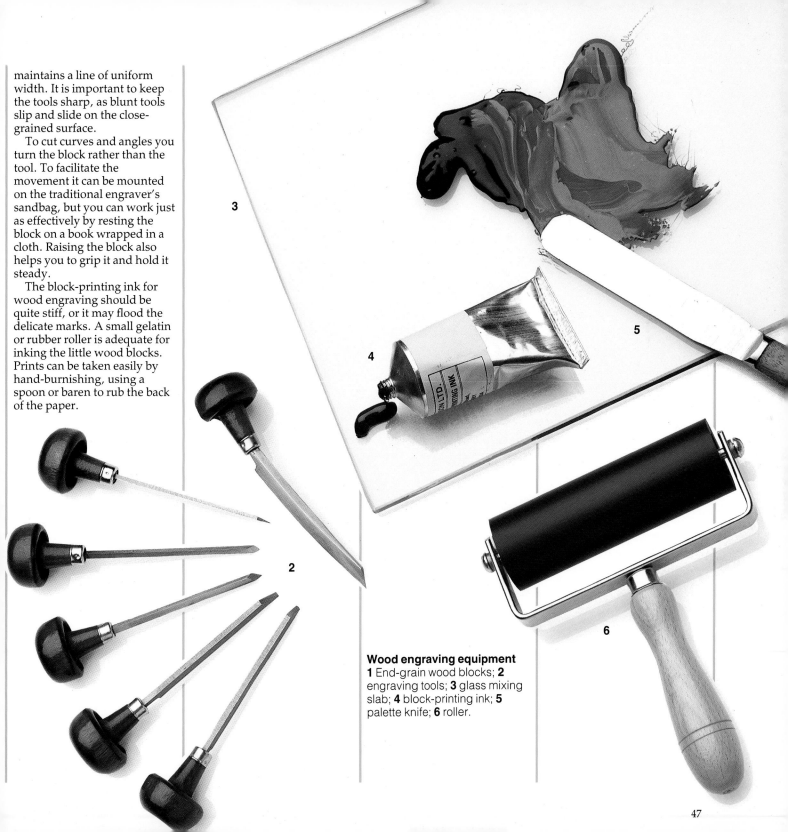

Wood engraving equipment
1 End-grain wood blocks; **2** engraving tools; **3** glass mixing slab; **4** block-printing ink; **5** palette knife; **6** roller.

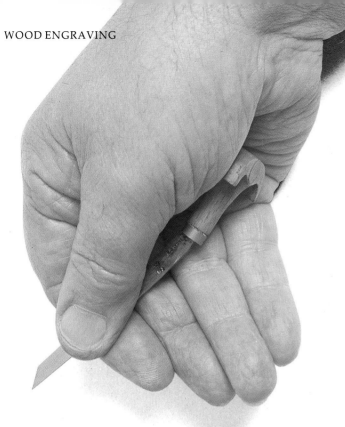

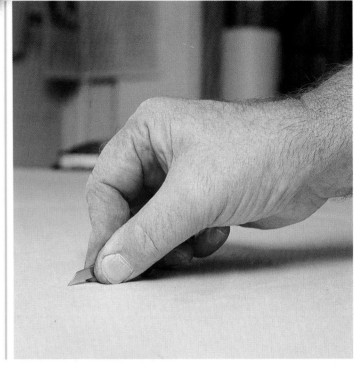

Holding the tools

1 Fit the mushroom-shaped wooden handle of the tool into your palm and support the metal shaft lightly with your fingers. Grip the shaft close to the cutting tip with forefinger and thumb.

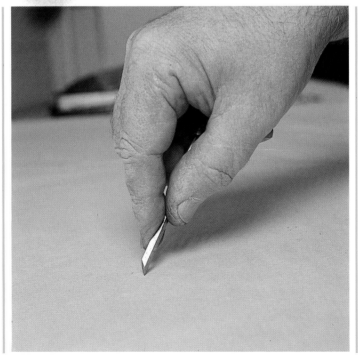

2 For engraving straight lines and curves, keep the tool at a shallow angle to the working surface, allowing the pressure of your whole hand to move it forward.

3 For short cuts, such as fine and coarse stippling, raise the tool at a sharper angle so that the action of the cutting tip is naturally abbreviated.

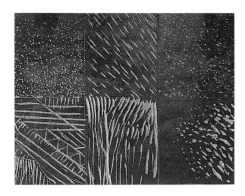

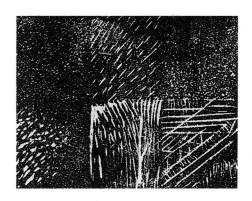

Marks of the tools

This test block and print show some of the variations of texture that can be achieved with different tools handled in different ways. On the print, these are: (top, left to right) stippling with a coarse graver; dashes cut with a spitsticker; close stippling with a fine graver; (bottom, left to right) short cuts with a scorper; lines cut with a scorper; lines cut with a spitsticker.

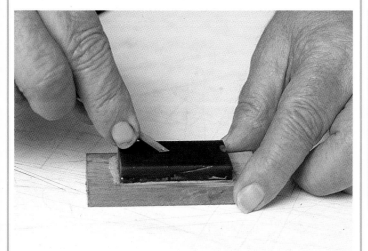

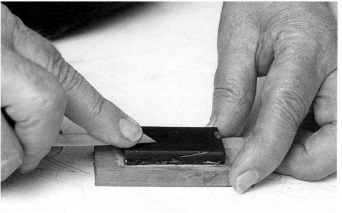

Sharpening tools

1 To sharpen a graver, put the facet of the cutting tip flat down on the oilstone and rub with a circular motion.

2 To sharpen a scorper, put the underside of the cutting tip on the oilstone and move it back and forth. Repeat with both flat sides of the narrow blade.

CUTTING THE BLOCK

A drawing can be made directly on the block or a prepared design can be traced down. If you are working in a way that produces a white-line image, you may find it easiest to darken the surface of the block with ink. You can then make your tracing with white transfer paper, so that the initial drawing corresponds to what you expect to see in the print.

For line work, the tool is held at a shallow angle to the block; the shape is designed for this, with the shaft broadly angled away from the wooden handle. The cutting needs to be quite slow and precise: because you are working on a small area, a too-forceful stroke can cause a significant error.

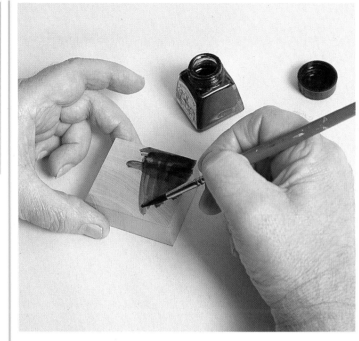

Drawing on the block
1 Paint the upper surface of the block with a thin coat of black drawing ink and allow it to dry completely.

2 Place a piece of white, or light-coloured, transfer paper on the block and put your drawing over it. Tape it to the edge of the block and go over the design in pencil to trace it down.

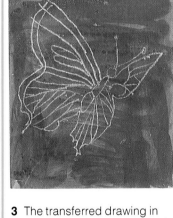

3 The transferred drawing in white on black gives an idea of the way the print will appear, but you do not need to fill in all the detail at this stage – this can be developed as you cut.

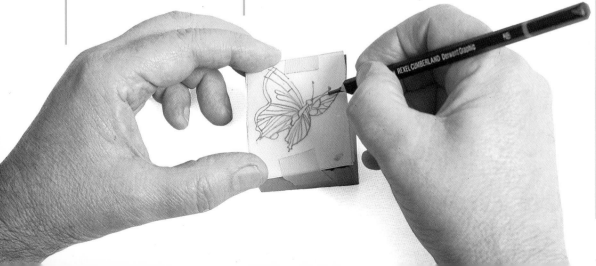

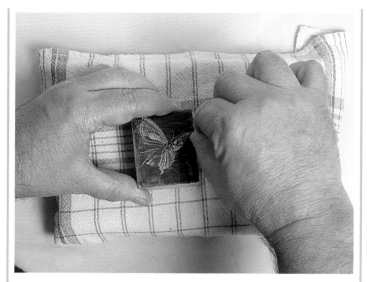

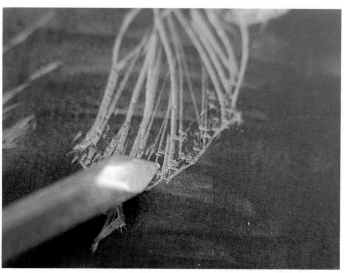

Cutting the block
1 Support the block on a raised surface while you cut, so you can hold it firmly by its edges. A book wrapped in cloth is the support used here.

3 The scorper is used to draw strong lines and to clear small areas of the block; note the shallow angle of the tip on the surface.

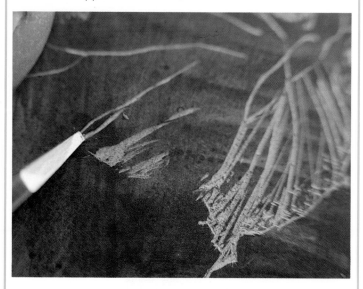

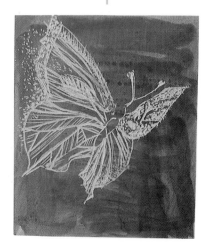

2 Work into different areas of the design with the appropriate tool. This picture shows a graver being used for stippled detail.

4 Work the cutting to a more or less finished stage before taking a proof. Most of the detail should be in place, with only minor refinements to do after proofing.

PROOFING AND PRINTING

Once you have inked the block to take a proof it is less easy to see the design clearly, as the ink will have stained some of the finer lines. Proofing is thus best left until the work is quite advanced. You can then make any refinements needed in the cutting before you take final prints. Do not clean off the ink with a solvent after proofing – just wipe it with a rag to remove the excess.

In keeping with the overall character of the process, the method of inking should be careful and controlled. You need only make one pass of the roller over the block in each direction. It is important not to over-ink the relief surface or the colour will spread into and fill the engraved lines.

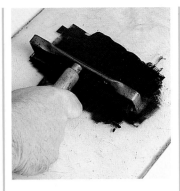

Proofing and printing
1 Roll out the ink on a glass mixing slab. Use quite a stiff block-printing ink so it will not flood the delicate lines cut into the wood block.

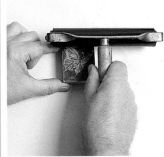

2 Roll up the surface of the block, being careful not to over-ink. You need only make one pass of the roller in each direction across the surface.

3 Use a lightweight printing paper that will pick up all the detail. Because the block is small, it is easy to take the proof by burnishing with the back of a small spoon. Place the paper on the block and rub it down firmly.

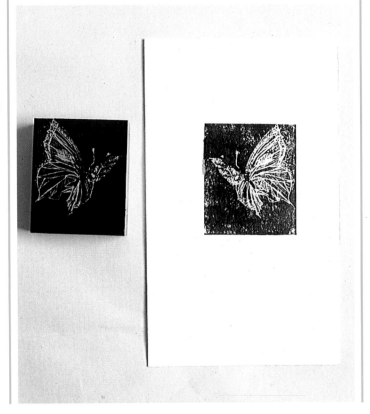

4 When you see the result of the proof, you can decide what further work is necessary before final prints are taken. Here, the artist decides some extra highlighting is needed.

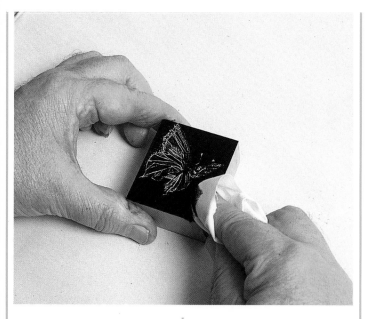

5 Before continuing to cut, wipe the excess ink off the block with a clean rag. Do not use a solvent, as this will flood the cuts and stain them, making it difficult to see the design.

6 As the final stage on this engraving, the artist uses a graver to cut a halo of fine stippling around the butterfly shape (below).

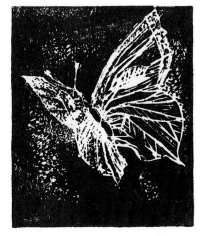

7 This attractive image demonstrates the small-scale character of wood engraving and the way it is necessary to balance the tones and textures by controlling the weight and direction of the various marks.

COLLAGE BLOCKS

This area of printmaking provides the opportunity to produce interesting and varied printed images without use of specialist materials and tools. The basic principle of relief printing, in which the design is formed by the contrast between positive (raised) areas of the printing block and negative (cut-away) sections, can be adapted to hand-made blocks constructed from a wide range of materials. These are assembled on a flat base to form a relief block with different surface levels. Suitable materials include paper, cardboard, fabric and string; found objects such as bottle tops and buttons; or acrylic mediums, which are applied in fluid form but dry to form hard, rubbery textures.

The technique has the same relationship to linocut or woodcut as collage has to painting. Instead of manipulating one material to create your effects, you combine different substances and textures. You ink with a roller as if it were a wood or lino block. To print, you can use the hand-burnishing* method of rubbing the paper down onto the inked block with a spoon or similar tool, though a relief printing press gives you a stronger, denser image.

The term collograph refers to a collaged block printed in the

9

2

1

same way as an intaglio plate*. To print the block effectively it must be run through an intaglio printing press, so the collage should not be too thick – about 8mm (¼in) – so it will pass between the rollers easily.

Tools and materials

The only tools you need are a craft knife and scissors for cutting your materials and a roller for inking up the block. Choosing materials for the collage is a matter of judgement and experience. It is not possible to predict absolutely the effect a particular material will make. Sometimes the roller picks up much more or less of the surface texture than you anticipate, though you can adjust the effects a little in the pressures you apply to inking up and printing. It is useful to experiment with small samples before selecting materials for a particular kind of image.

Among the simplest and most readily available materials are different kinds of card and papers – you can save offcuts and packaging materials, looking for varied weights and textures. String, wool, ribbon and braid are all effective. Adhesive tapes are useful for forming linear and geometric motifs.

An all-purpose acrylic adhesive such as PVA or Marvin medium works as both the means of glueing materials to the support and as an independent printing element. The viscous white medium can be thickly applied with a pen, brush or knife; it dries into a clear, rubbery surface that retains its original texture and prints well. It also makes an excellent binder for loose-textured materials such as sand or rice.

The number of impressions you can take depends upon the resilience of the materials you have used – the surface will eventually break down, especially if some of the materials are absorbent. Sealing the surface with a thin application of acrylic medium makes the collage more durable.

FURTHER INFORMATION

*Linocuts: Proofing and printing, pages 31–33
*Intaglio printing: inking and wiping; taking the print, pages 106–107

Equipment for collage blocks
1 Buttons; **2** wood shavings; **3** pulses; **4** yarn; **5** pasta; **6** PVA adhesive; **7** scissors; **8** craft knives; **9** paper and card.

Braid and yarn
Scraps of fancy braids and yarns from a knitting or sewing basket contribute unusual pattern qualities. Because the materials are absorbent, you may need to ink and print a few times before the full impression comes through.

Cardboard
In addition to selecting different textures and thicknesses of cardboard to create variations in your print, you can cut into the surface and peel back the top layer to make hard edges and rough, broken textures.

Sandpaper
The gritty surface of sandpaper prints a fine pattern of irregular dots. The solid colour at the top edge of this section comes from tearing the material so that the abrasive layer is pulled away, leaving only the base paper.

String
Pieces of string create distinct, fine lines, but with a pleasing burred texture. Different effects will be obtained according to the weight and thickness of the string and the fibres from which it is made.

Adhesive tapes
Masking tape has a rough finish that prints as a mottled or striated texture. Smooth, finer tapes allow the ink to print off more evenly. The edges print as dark or light lines, depending on the thickness of the tape.

Split peas
Loose materials such as pulses, sand or wood chippings can be glued to the collage base by pressing them into a layer of acrylic medium and allowing it to dry. The patterns that print are more random than you might expect, in this case because the hard peas have irregular surfaces.

Rice
A hand-proofed print from a layer of rice stuck in acrylic medium produces a coarse stipple effect. With all such materials you will obtain a slightly stronger texture if you print on a press, because of the more intense, even contact between printing surface and paper.

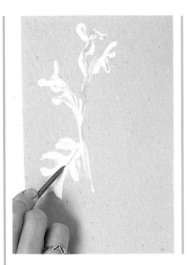

Glue painting
1 A thick acrylic adhesive can be painted onto cardboard in rough shapes and drawn into with the wooden end of the paintbrush, or with a pencil. The medium is opaque white while wet, so you can see what you are doing, but dries clear.

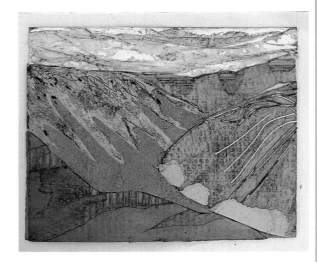

Making the collage
1 The materials are glued to a cardboard base; let the adhesive dry completely before printing. This example is a hilly landscape constructed from various thicknesses and finishes of cardboard, sandpaper, string and crumpled tissue for the sky.

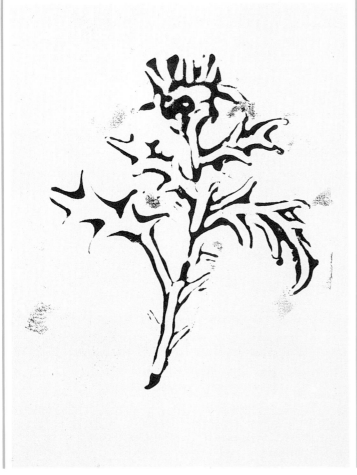

2 Because the medium is applied in liquid form, the surface areas are slightly curved, which becomes more apparent as the glue painting dries. In this case only the highest ridges have printed, giving the effect of a free, bold line drawing.

2 In the first proof the softer cardboard layers reveal a "honeycomb" texture under the pressure of printing. This appears too evenly distributed and mechanical, so additional materials are added to the block.

3 This proof has a more satisfactory contrast of textured and solid colour areas. In the foreground, thin card pieces create strong black shapes; the upper slopes of the hills are more densely textured where a thick layer of acrylic medium has been loosely brushed on.

SCREENPRINTING

HAND-CUT STENCILS

PAPER STENCILS

FILLER STENCILS

TUSCHE METHOD

The principle of screenprinting is somewhat different from that of the other printmaking processes in that the print is taken not by the direct impression of one surface upon another, but by printing through an intermediary surface – the screen mesh. The images of screenprints are formed by various kinds of stencilling techniques, based on blocking out areas of the mesh either with sheet materials such as paper or stencil film or with liquids that fill the mesh.

As well as being a fine-art process, screenprinting has a direct association with commercial and industrial printing processes, being used extensively in graphic, ceramic and textile design. It is a colourful, versatile medium which you can adapt to the context of your work.

Tools and materials

The basic equipment consists of the screen – a wooden frame with a fine-mesh fabric stretched over it – and the squeegee. This is a rubber blade set in a handle, with which the screen ink is pulled across the mesh. The mesh transmits an even coating of ink which adheres to the paper below the screen.

The stencil, whatever its form, seals certain areas of the screen so that the ink cannot pass through, thus creating positive and negative colour areas. The stencil can be a material as simple as thin paper that will adhere to the underside of the mesh – for example, newsprint, tracing paper or greaseproof paper. Stencil film is a gelatinous material on a plastic backing that can be cut with a sharp craft knife – when soaked with water it softens and is pressed into the mesh before the backing is removed. A similar effect can be obtained with self-adhesive plastic film applied to the screen, and you can also use adhesive tapes.

2

6

Paper and film stencils produce clean-cut, hard-edged images.

Materials that are pre-cut and then applied to the screen are known as indirect stencils, while those which are applied by painting and drawing are called direct stencils. "Liquid stencils", or screen fillers, may be water-soluble, oil-based or cellulose. The type you use depends on the type of ink, as the filler must remain resistant to the solvent of the ink so that the stencil remains intact when you print and clean the ink from the screen. Commonly, water-based fillers are used in combination with oil-based inks*. Conversely, you can combine oil-based filler with water-based inks. Cellulose filler is impervious to both oil- and water-based inks, but has to be cleaned from the mesh with a special solvent.

FURTHER INFORMATION

*Screenprinting: filler stencils, page 70–73

Screenprinting equipment
1 Squeegee; **2** screen; **3** screenprinting inks; **4** palette knife; **5** solvent brush to remove stencils; **6** cleaning rags.

HAND-CUT STENCILS

The advantage of using hand-cut stencils is that all the elements of the printed image are prepared away from the screen. If you get something completely wrong, you can remake the stencil. When cutting film stencils, you can see through the material, so it can be placed over a working drawing to guide the cutting.

When you plan the image you must take into account that paper or film stencils give you hard-edged, graphic shapes. Each colour to be printed requires a separate stencil. If the ink is fairly transparent you can obtain colour "mixtures" by overprinting one hue on another, and build up quite complex effects of pattern and form by varying the shapes and details of each overprinting. The process of registering colour printings on the screen bed is quite simple.

Where colour areas are to be butted together you should allow a very tiny overlap when cutting the separate stencils for each colour, as otherwise you may get a white line between them as you print the colours individually. The demonstration sequence shows both the processes of preparing hand-cut stencils and the basic methods of inking and printing. The simple technique of laying out ink and pulling the squeegee across the mesh is standard however the screen stencils are prepared.

Preparing hand-cut stencils
1 Stencil film has two layers – the coloured stencil and a clear backing sheet. Use a fine scalpel to cut lightly into the top layer. Here the artist is using a working sketch slipped under the stencil as a guide.

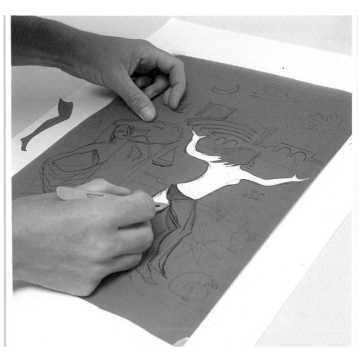

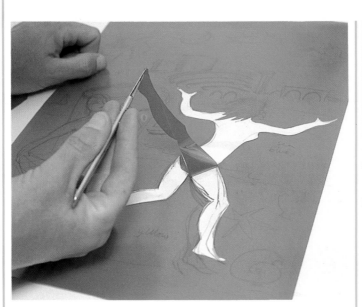

2 When you have cut a shape in outline, use the point of the knife to lift one edge or corner, then peel back the cut shape.

3 Prepare stencils for each of the colours you are to print and check that the shapes align by overlaying them one on another. In this demonstration, six colours are to be printed: pink, yellow, light blue, red, mid-blue, black.

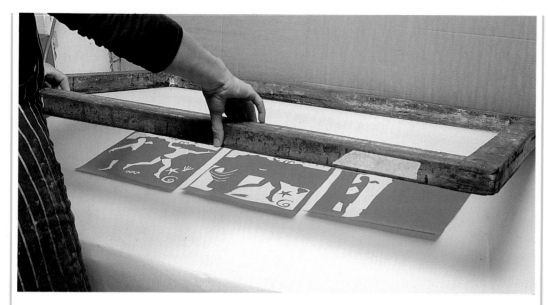

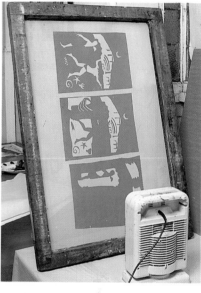

4 Position the stencil under the screen mesh. Because a large screen is used here, and the stencils are relatively small, the artist is placing three stencils side by side on one screen.

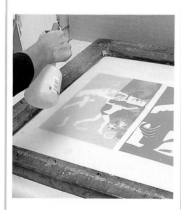

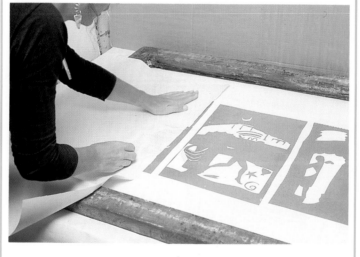

7 When all of the stencils adhere to the screen, allow them to dry out completely. You can speed up the process by using a hot-air dryer.

5 Lower the screen so the mesh lies flat on the stencil and spray clean water on the mesh. This softens the stencil material so it will adhere to the screen. You must move quickly to the next stage.

6 Lay a clean piece of newsprint over the screen and blot firmly with your hands, creating pressure that sticks the stencil to the mesh. Because this has to be done quickly, if you are putting more than one stencil on the screen, do each in turn rather than all together.

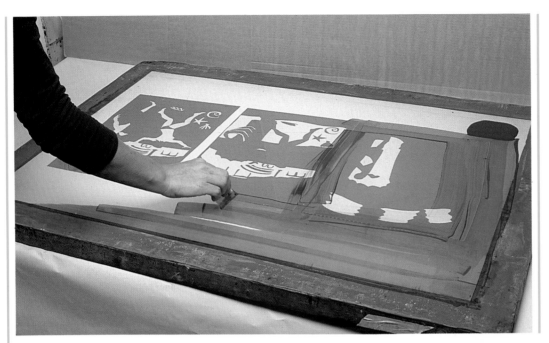

8 To block out the open areas of the screen mesh surrounding the stencils, turn the screen upside down and spread a liquid filler around the borders.

The simplest way to do this is to use a small piece of card to pull the liquid across the mesh.

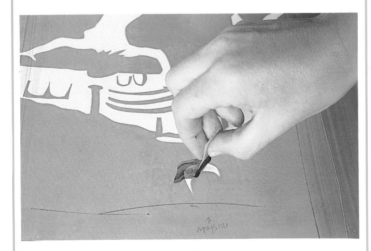

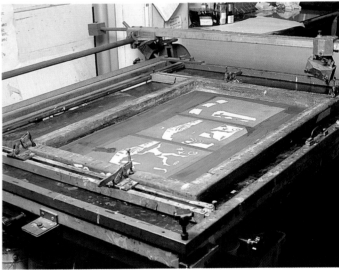

9 Any errors on the stencil can be blocked out in the same way. Here the artist fills in a shape that is not intended to appear in the colour that this stencil will be printing.

Printing technique

1 This demonstration shows printing on a screen frame attached to a vacuum-bed printing table. The screen is securely locked into the frame. The lowered screen does not quite lie flush with the bed – a small gap, known as "the snap", allows for the "give" in the screen mesh when the squeegee passes over.

2 The plastic backing on the stencils must be removed before they can be used to print. Take hold of one edge and peel the backing off smoothly.

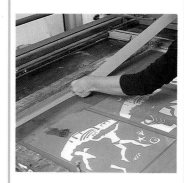

3 Tape the edges of the screen all round to form a reservoir for the ink and ensure that no colour bleeds under the mesh where it joins the screen frame. You can use gummed paper tape or self-adhesive tape.

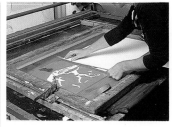

4 If you have more than one stencil on the screen, use paper to cover those not printing at this stage. This keeps them clean and prevents ink bleeding through beyond the borders of the first stencil.

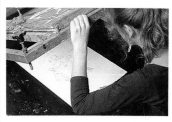

5 You need to put registration marks on the screen bed so the image is correctly positioned on the paper. The artist uses the original working sketch to locate the printing area.

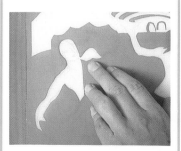

6 The sketch is moved around until it is accurately aligned with the stencil image. This picture shows the screen lowered and the artist checking the alignment through the mesh.

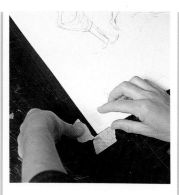

7 When the paper is in the correct position, the left-hand lower corner and edge are marked with pieces of masking tape stuck to the screen bed. The printing paper will be positioned against these guides each time the first colour is printed.

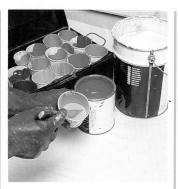

8 Mix your ink colours in sufficient quantity to allow for the required number of prints. Screenprinting ink is a thick liquid and is commonly mixed in waxed-paper cups; any leftovers can be stored this way.

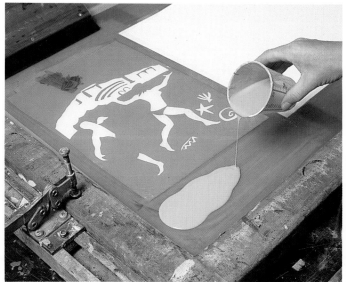

9 Pour the ink in an even flow across the bottom border of the screen, below the image. It puddles outwards but, because it is viscous, does not flow into the stencil area.

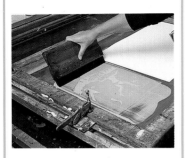

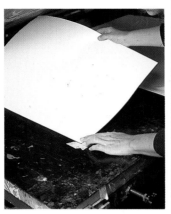

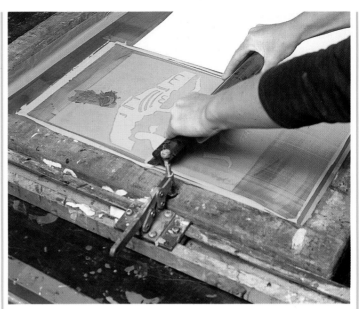

10 Lift the screen slightly and use the squeegee to push the ink back across the mesh, flooding the colour into the image area.

11 Position the clean piece of printing paper on the screen bed, aligned to the register marks previously taped in place. Lower the screen over the paper.

12 Place the squeegee in the layer of ink at the top of the screen and pull it firmly and evenly across the image area. You must use a squeegee that covers the whole width of the stencil, and keep it firmly horizontal as you pull.

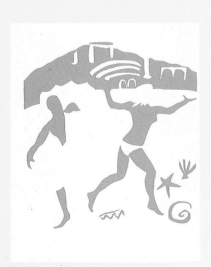

Stage proof: one

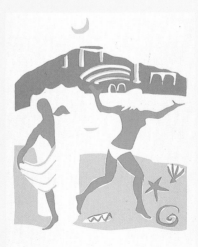

Stage proof: two

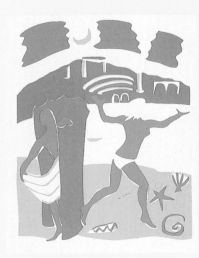

Stage proof: three

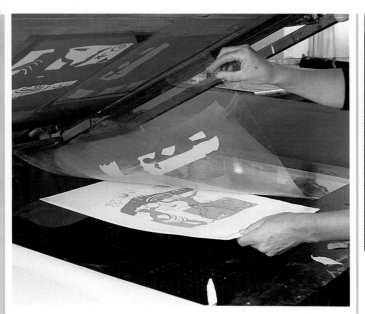

Registering overprintings
1 To register the second and subsequent colours quickly and accurately, the artist uses an acetate sheet attached to the screen bed on one side. The single colour is printed on the acetate. Then the print is placed underneath.

2 The print is moved around until it aligns exactly with the newly printed colour on the acetate. Then the positions of the bottom corner and left-hand edge are marked with tapes on the screen bed, as before.

Stage proofs
This sequence (below) shows how the image develops new form and depth with each colour printing. Notice, in the second stage, that the overprinting of transparent yellow on pink has produced a "mixed" colour – a warm orange. Although each stencil image consists of hard-edged shapes, the artist has successfully achieved a free, lively style of image by using small shapes and patterns to break up the broad colour areas. She keeps the final, black printing very linear, to sharpen the detail.

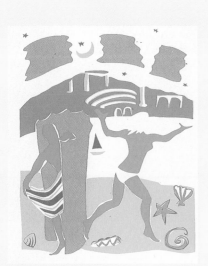

Stage proof: four

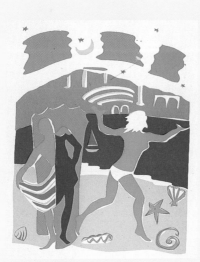

Stage proof: five

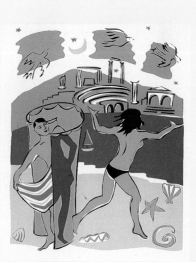

Stage proof: six

PAPER STENCILS

Using newsprint or tracing paper for your stencils is ideal for the beginner in one respect – it enables you to experiment inexpensively. However, remember that a paper stencil is naturally less durable than film. You can draw direct on paper or trace from an original drawing and cut with knife or scissors. The paper pieces laid on the screen bed adhere to the mesh with the first pass of squeegee and ink, so you do not need to have links between all the shapes. "Floating" pieces must be positioned carefully at the start, but will then become self-adhesive.

Even if you keep to a fairly simple design you can create exciting variations by trying different ways of inking. Colour blends and variegations are easy to form on a screen. This demonstration also shows the use of talcum powder to obtain a mottled texture: the talc is pressed into the mesh at the first inking and forms a block in the same way as a sheet material or liquid filler.

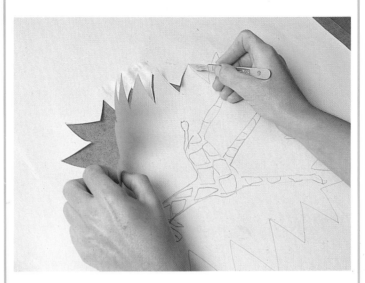

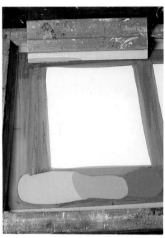

Paper stencil
1 A simple design is freely cut from newsprint, a starburst with an animal figure inside. You can use freestanding shapes within a paper screen stencil, as each piece individually adheres to the screen mesh.

3 Lay out the ink along the bottom of the screen. To make a blend of colours, pour a small pool of each colour and let them flow gently together.

2 Position the printing paper on the screen bed and mark the corner. Lay the paper stencil over it in the required position. You can put pieces of double-sided tape at the corners to help the stencil attach to the screen.

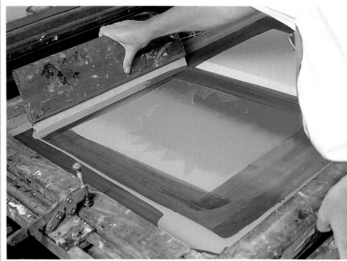

4 Lift the screen and flood the colour back into the mesh by pushing the squeegee upward. Then lower the screen and pull the other way to make the print.

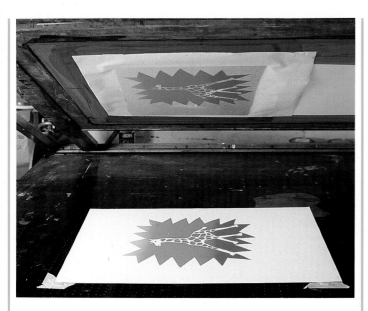

8 It is easy and economical to experiment using these techniques. This example has been printed using the discarded section cut out of the previous stencil. The giraffe appears this time as a positive image, while the starburst is the negative shape.

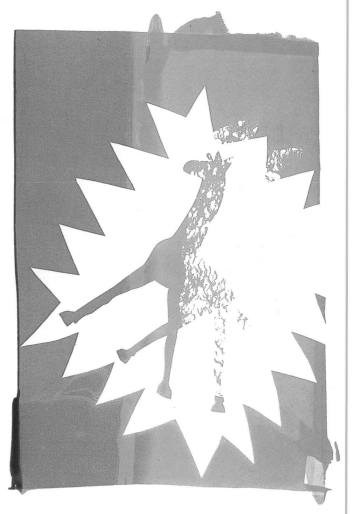

5 The starburst shape and the cutout of the giraffe can be seen sticking to the underside of the mesh, while their silhouettes are clearly printed on the paper in the warm colour blend.

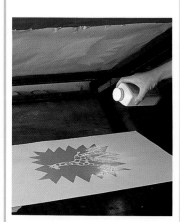

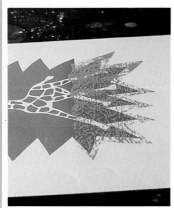

6 To add texture using talcum powder, make a paper stencil outlining the shape to be printed and attach it to the screen. Shake talc freely but loosely onto the print.

7 Lower the screen and print the required colour in the usual way. The movement of the squeegee presses the talc into the screen mesh, acting as a block to the ink. This forms a random, lacy pattern.

FILLER STENCILS

Painting on the screen mesh with liquid filler is a satisfyingly direct way of working, enabling you to produce more free and painterly effects. The main drawback for the inexperienced printmaker is that the design has to be worked out negatively – the brushmarks create the non-printing areas. However, because you can see through the screen mesh, you can place a working drawing underneath to guide you as you paint the stencil image; then it is only a matter of concentration.

This demonstration sequence also shows how effectively you can utilize overprintings of semi-transparent colours. The artist uses the process printing colours – cyan (blue), magenta (red) and yellow – with a final overprinting in white. She achieves dark tones such as green and purple, as well as tints of pale blue and pink. This is the same principle as applied in commercial printing, where variable combinations of the process colours achieve an almost infinite colour range – the colour photographs in this book are printed using only cyan, magenta, yellow and black.

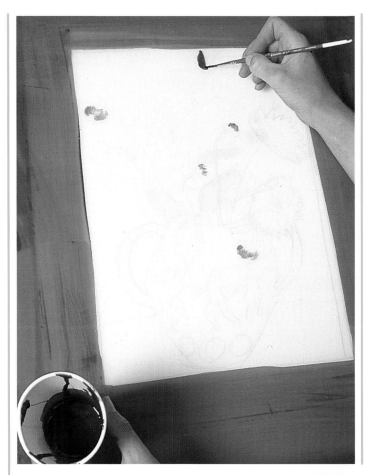

Using filler
1 When painting the filler directly onto the screen mesh, you may find it easiest to place a working drawing or sketch under the mesh as a guide, as shown here.

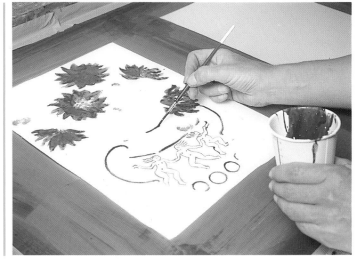

2 In this example, the artist begins with a stencil that will print blue. To allow for overprintings that will form mixed hues, only the flowers and outline pattern on the vase are blocked out.

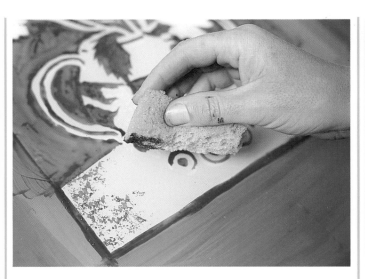

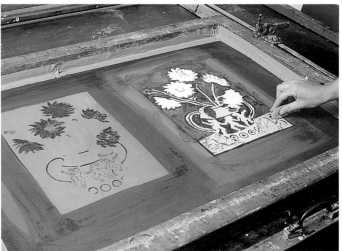

3 The second colour to be printed is red. Only those areas to remain pure blue are blocked out. The artist applies a sponged texture to the foreground area.

4 The background will remain blue and is fully blocked out, leaving the shapes of the flowers, vase and tabletop to print in red.

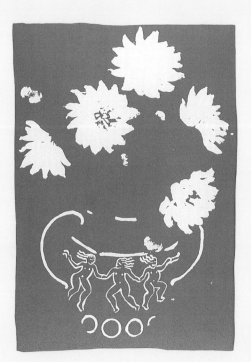

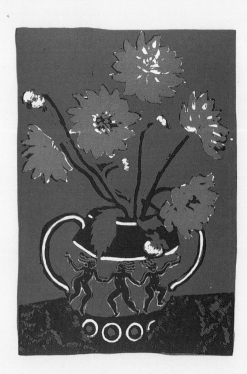

Stage proof: one
The first printing (left) shows broad areas of fairly solid, uniform colour with little detail visible at this stage.

Stage proof: two
Where the red has overprinted on the original blue (right), a rich, deep blue-purple is formed that gives depth and weight to the image. Flashes of the white paper remain where the mesh has been blocked out on both stencils.

(Stage proofs continued on page 73.)

5 The same process is applied to preparing and printing the third stage of the image – the transparent yellow layer.

6 White ink will be used in the last stage, to vary the tones and enhance the textures. The artist prepares the final stencil exactly, by working to the existing print, placed underneath the screen.

7 The white ink is flooded onto the screen and the print is pulled by drawing the squeegee downwards.

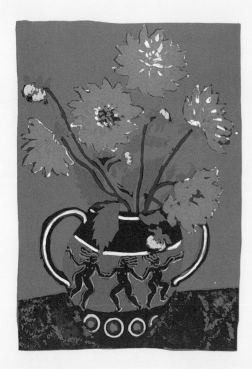

(Stage proofs continued from page 71.)

Stage proof: three
The yellow overprints on both the blue and red, producing green and scarlet respectively (left). This completely transforms not only the colour balance of the image but also the description of the shapes.

Stage proof: four
The white ink creates paler tones of all the original colours, and where it is printed over red and blue, it makes a neutral, warm grey (right). Using only four colours, the artist has produced a wide range of hues and tones and some fascinating textures.

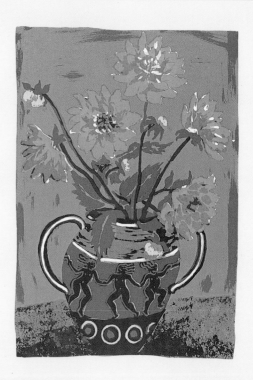

2 Wash the ink out of the stencil with the appropriate solvent. In this demonstration, oil-based ink is being cleaned off with white spirit.

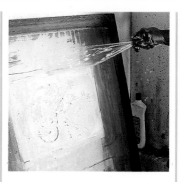

3 When printing from one stencil is complete, it can be cleaned out of the screen mesh. Here, water-based filler is flushed out with a spray jet: the screen stands upright in a purpose-made trough. Stubborn traces of filler can be scrubbed with a soft brush.

Cleaning the screen
1 Between each printing, you must clear the screen of ink. Use the squeegee to collect excess ink into a puddle, then pick it up on a palette knife.

TUSCHE METHOD

The method of preparing stencils by the tusche method is similar to the filler method, but there is one crucial difference – this is a resist technique which produces a "positive" stencil. The image is drawn up with tusche (drawing ink) and/or lithographic crayon, both of which are oil-based materials with a greasy texture.

The finished drawing on the screen mesh is coated with gum arabic and is allowed to dry. This acts to block the mesh, as does blue filler, but does not adhere to the tusche. The image is then washed out with white spirit, but the gum arabic, being water-soluble, remains in place. The open areas of the stencil are now those marks that you originally drew and painted, so that the printed image is a positive reading of what was first applied.

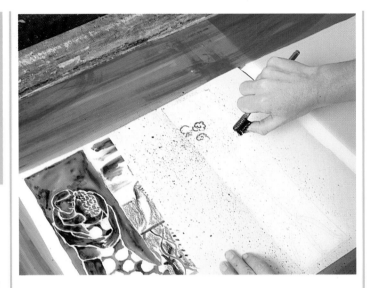

Using tusche
1 Work directly on the screen with tusche, using any typical painting techniques. This picture shows spattering applied with a toothbrush between paper masks, after parts of the image have been drawn with a paintbrush.

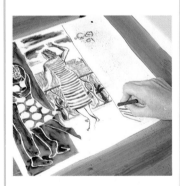

2 Lithographic crayon can also be used to give a different quality of line. Technically, it acts on the screen mesh in the same way as the tusche. To make the first stencil you can draw quite freely, or follow a working sketch or painted study if you prefer.

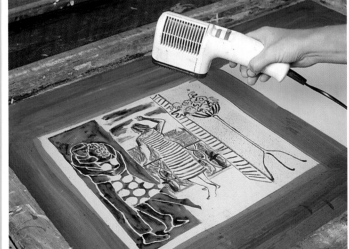

3 Allow the painting on the mesh to dry out completely before moving on to the next stage. To save a long wait, you can use a hairdryer to speed up this process.

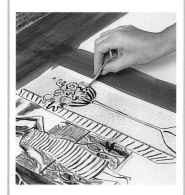

4 Spread a thin layer of gum arabic over the whole image area. Use a small rectangle of card or plastic to help coat the mesh quickly and evenly. Allow the gum to dry.

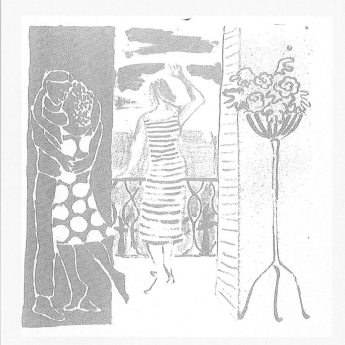

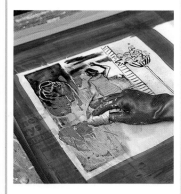

5 Wash out the tusche image with white spirit applied with a rag or sponge. This has no effect on the gum arabic, so you are left with a gummed stencil consisting of the negative areas of your drawing; therefore the positive marks will print.

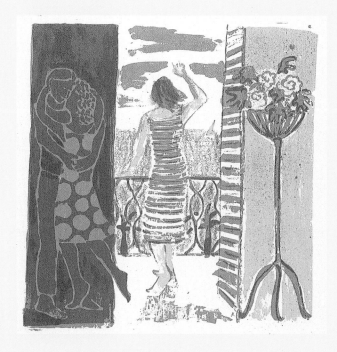

Stage proof: one
The first printed image has a fresh, painterly quality with interestingly varied textures. The rough shading of the sea was made by a frottage technique, placing the mesh over a board, then rubbing over it with the litho crayon.

Finished print
Second or subsequent colours can be printed by preparing stencils in the same way, using the original print or your working sketch as a guide. The mid-toned green and pale flesh tint applied here maintain a bright, airy quality appropriate to the subject, while overprinting on the left-hand side introduces an effect of deep shadow.

DRYPOINT

DRAWING ON THE PLATE

(For how to print drypoint, see pages 102–109.)

Because it is the simplest and most direct of the intaglio processes, drypoint is an interesting introduction to working on metal, especially if you have limited access to printmaking facilities. The technique consists of scratching into the surface of a metal plate using a strong, sharp point. The point is used to score the surface, which causes a ridge of metal – called the burr – to be thrown up on one or both sides of the line. This burr holds more ink than

1

2

3

4

Drypoint equipment
1 Combined drypoint needle and burnisher; **2** drypoint needle; **3** combined scraper and burnisher; **4** zinc and copper plates.

the relatively shallow scratches and contributes a velvety, rich quality to the impression.

Drawing on the plate with the point is directly comparable to drawing on paper, though you must use sufficient pressure to mark the metal effectively. But it is an informal process, immediately accessible to anyone with some drawing ability. Its main disadvantage in comparison with other intaglio printmaking methods is that the burrs wear down quickly under the normal actions of inking the plate and passing it through the press, so the number of good-quality prints that can be taken is limited.

Tools and materials

The only materials needed are a plate and a point. Copper or zinc plates are commonly used. Zinc, being a softer metal, is easier to work but produces fewer good impressions. For the drawing tool, a hard steel needle or scriber with a smooth, unfaceted point is generally adequate; the alternative is a point made of precious stone such as diamond.

Because of the relative fragility of the drypoint image, working proofs that allow you to check the progress of the drawing must be kept to a minimum. The plate can be prepared without access to any studio facilities; for inking and printing techniques, see the chapter on intaglio printing*.

FURTHER INFORMATION

* Intaglio printing, pages 102–109

DRAWING ON THE PLATE

Any of the effects associated with line drawing can be expressed through drypoint. You can vary line qualities by altering the pressure and angle of the tool, using the point to score or pick at the metal. The burr is raised most consistently by holding the tool upright or at a steep angle; if the point goes in at too shallow an angle there is a danger that it may undercut the burr and lose the richness of the line.

The character of the drawing can rely mainly on outline or contour, but if you want to introduce tonal areas you can do so by means of conventional drawing techniques such as hatching and crosshatching with close-set parallel lines, or a form of stippling achieved with short, stabbing marks. However, the final state of the print need not depend solely on the positive marks made by the point; you can also use a scraper or burnisher to remove the burr, thus lightening up an area that has been overworked.

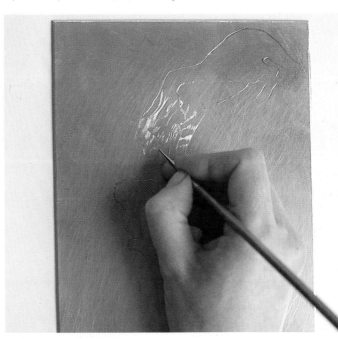

1 Start to draw on the plate with the needle as you would with a pencil on paper. It is easiest to sketch out a few faint guidelines first, then gradually strengthen the lines and develop the textures.

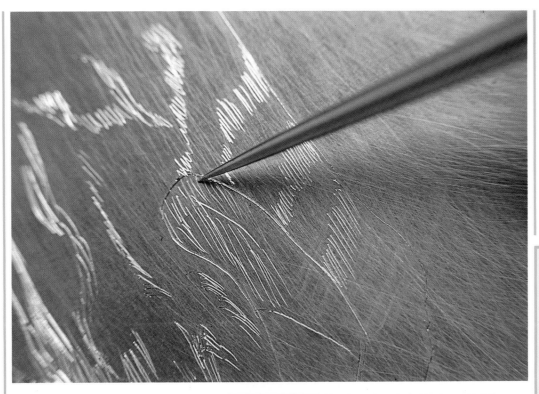

2 Changing the angle of the tool enables you to create more or less burr on the line, while more pressure gives you increased thickness. Try to vary the line qualities expressively, according to the details of your subject.

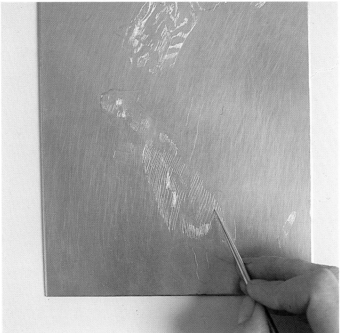

3 You can create greyed areas by hatching blocks of fine parallel lines. The closer the lines and the more burred the marks, the heavier the tonal emphasis will be.

Finished print
The first prints from the finished plate (near left) have a very rich tone, with dense blacks on the darker cat. This is due to the heavy burr created by the stippled marks. After several impressions, you can see how the dark tones have faded (far left) as the burr wears down in printing – individual marks are visible on the cat's back. Altogether ten acceptable prints were taken from this plate.

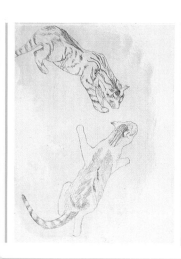

4 Once the design is fully drawn out, take a proof to check the image. In this example (left) the shapes are judged to be satisfactory, but the tones are not yet rich enough.

5 The drawing is worked much more heavily on the plate with hatched and stippled textures. A second proof is taken (right) as work on the plate nears completion and, using this as a guide, some unwanted lines are smoothed out with the burnisher.

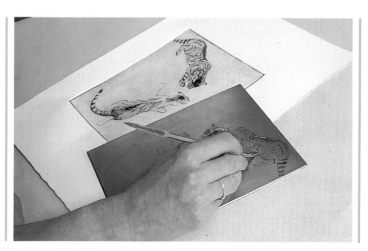

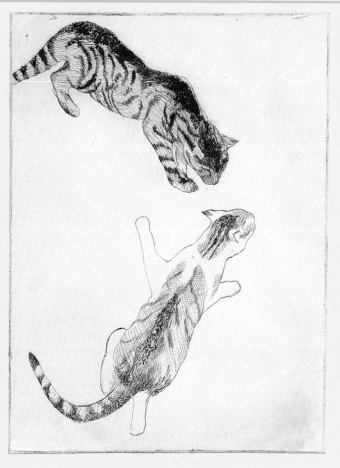

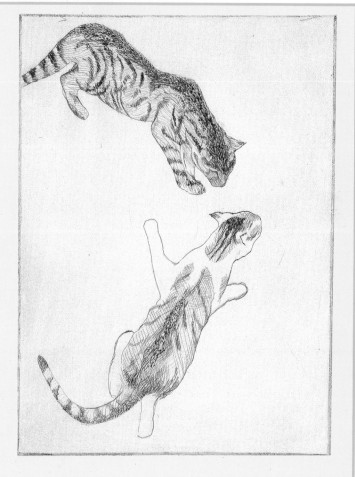

MEZZOTINT

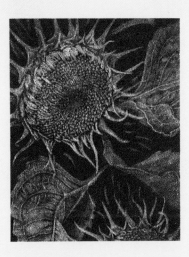

ROCKING THE PLATE

SCRAPING AND BURNISHING

(For how to print mezzotints, see pages 102–109.)

Mezzotint is an unusual intaglio process in two respects. Preparation of the plate requires quite intense physical labour; and the image is worked light out of dark, a reversal of typical approaches in drawing and printmaking. Before any creative work can begin, the plate surface is systematically roughened to produce an overall texture that prints as an even, dense black. Mid-tones and whites are retrieved by smoothing out this texture to varying degrees.

The tonal emphasis gives mezzotint prints a soft, often atmospheric quality with minimal linear structure. The technique was invented primarily as a reproduction process that would provide a more painterly effect than line engraving, allowing subtly fluid gradation of tone. It has not been consistently exploited as a creative medium in its own right, and the tedious, purely mechanical aspect of "rocking" the plate to achieve the initial tone can be a deterrent. However, the character of the mezzotint impression is

Mezzotint equipment
1 Coarse mezzotint rocker; **2** fine mezzotint rocker; **3** copper plate; **4** burnisher; **5** curved scraper.

unique, and the transition to pale tones, even high whites, out of intense, rich darks can have great dramatic impact.

Tools and materials
Copper plate is used for mezzotint, and the tool for creating the rough ground is the mezzotint rocker, a broad chisel-like implement with a curved, toothed blade. The

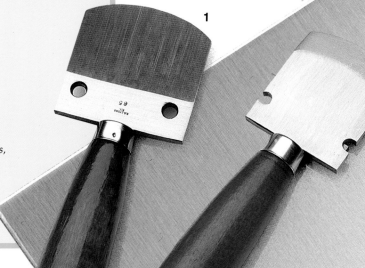

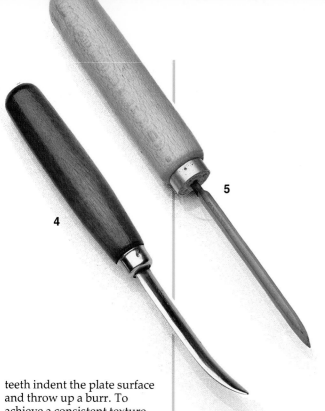

4

5

3

teeth indent the plate surface and throw up a burr. To achieve a consistent texture, the rocker has to be moved gradually all over the plate in all directions, and a rocking pole is often used to assist the action. Rockers are made in several sizes with teeth differently spaced – fine, closely set teeth give the most

consistent tone; a coarse rocker creates more burr and therefore provides the densest blacks, but with a less even texture overall. If you wish to try out the effect of mezzotint without having to do the hard work of preparation you can obtain pre-rocked plates. These are mechanically prepared, with an even texture, but they are expensive.

The process of "drawing" on the plate – bringing back the lighter tones – involves removing or smoothing down the burr using a scraper and burnisher. To rework an area where you have taken out too much of the tone, you can use a roulette – a small, serrated wheel set in a handle, which can be rolled across the plate to enhance detail or repair the ground. Roulettes are available in different shapes and sizes.

ROCKING THE PLATE

The reason why rocking the plate is such a laborious process is that it must be done quite consistently in several different directions – first at right angles to the sides of the plate, then along diagonal paths from the edges. The time it takes depends partly on the size of the plate in relation to

the width of the rocker; a very large plate may take days to prepare.

A grid of parallel lines is drawn up to guide the tool, which is held upright on the surface and rocked from side to side on the curved blade, at the same time moving gradually forward along the grid lines. When the rocker is hand-held, the movement comes from forearm and wrist rather than just the hand. The weighted rocking pole relieves some of the strain of this action by contributing a consistent pressure and keeping the tool on a straight path.

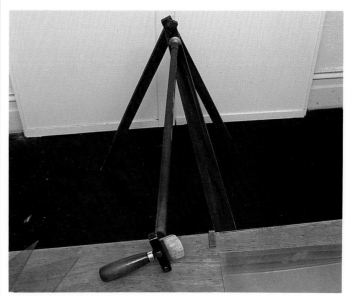

Using the rocker
1 If you are working on a large plate, using a rocking pole helps to lighten the physical effort of rocking the texture initially. The weighted pole can be supported on a frame that

allows it to rock easily while keeping a consistent direction, or it can be rested on the work surface.

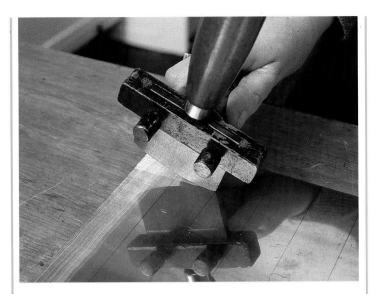

2 Grasp the pole right behind the point where the rocker is attached and rock it steadily from side to side, at the same time gradually pushing it forward across the plate.

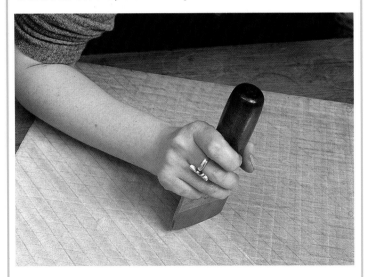

3 You can alternatively rock without the pole, which puts more pressure on your forearm. The plate must be rocked in many different directions to obtain a dense texture, indicated by the grid lines visible here.

SCRAPING AND BURNISHING

Individual or combined processes of scraping and burnishing can be used to develop the variation of tones. The scraper removes the burr and the burnisher polishes the surface; to work back to pure white, both tools must be used. Intermediate greys can be formed by scraping and burnishing to different degrees or just by using the burnisher gently to flatten the burr. The only way of finding out the extent and degree of either action required for a particular effect is through experience.

To give yourself a layout for the design, you can start by drawing on the roughened plate with a soft pencil. You can also rub ink into the plate so that you are working on a black surface, which helps you to estimate the effect of the scraping and burnishing. If you do this, clean off the ink each time you stop work or it will dry hard and you may damage the burr of the plate while trying to remove it. Keep proofing to a minimum, as the printing process gradually wears down the texture. For printing mezzotints, see the chapter on intaglio printing*.

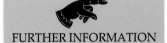

FURTHER INFORMATION

*Intaglio printing: pages 102–109

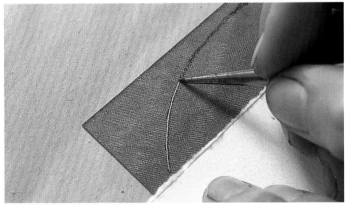

Drawing on the plate
1 Guidelines for the design can be drawn on the metal using a soft pencil. Where a sharp outline is needed, draw into the rocked texture with a metal scriber.

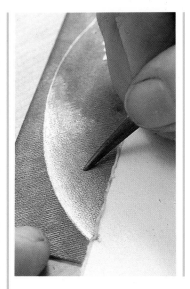

2 The curved tip of a burnisher flattens the burr on the metal plate. The shaded area will print as a light tone, graduating to dark as it recedes from the outline.

3 You can work with a scraper to clear very pale-toned areas quickly. This has a less delicate effect than a burnisher: it is a matter of personal preference which to use, according to the character of the design.

Philip Coombs
Doll's Head (Mezzotint)
The graded tones of mezzotint have an almost photographic quality when applied to heavily modelled shapes. The strong black of the fully rocked texture, as seen in the background of this image, has a rich, velvety intensity.

ETCHING

PREPARING THE PLATE

APPLYING HARD GROUND

DRAWING ON THE PLATE

BITING THE PLATE

AQUATINT

SOFT-GROUND ETCHING

SUGAR-LIFT PROCESS

ETCHED TEXTURES

(For how to print etchings, see pages 102–109.)

The essential difference between etching techniques and the other intaglio methods is that the marks are not achieved by incising or scraping the metal. The image is developed by corroding the metal plate with acid, using acid-resistant grounds to protect the areas not to be etched.

The variety of materials and techniques that can be applied to etching makes it a remarkably versatile and expressive area of printmaking. Different ways of manipulating the grounds, the mark-making processes, the action and extent of the corrosion, and the printing process give the artist an infinite range of creative opportunities.

Tools and materials

To produce even the most basic etched impression you will need quite a wide range of materials and equipment, and it is essential to learn the techniques under supervision in a properly equipped studio. Safety factors are particularly

Etching equipment

1 Hard ground; **2** soft ground; **3** stopping-out varnish; **4** liquid hard ground; **5** zinc and copper plates; **6** leather-covered dabber; **7** burnisher; **8** etching needle; **9** scraper; **10** feathers for clearing acid bubbles from plate; **11** clamp for holding plate during smoking.

important. At various stages the plate has to be heated on a hotplate or burner, and the process of etching involves using an acid bath which should be sited well away from other work areas and must be well ventilated to remove fumes.

The simplest range of etching equipment consists of a metal plate, acid-resistant ground and varnish, an etching needle and an acid bath. Copper or zinc plates are

3

4

5

7

8

9

usually chosen, although steel and other metals are also suitable. Copper provides more refined effects of line and tone and, being harder, stands up better to the wear and tear of inking and printing. But zinc (or a zinc-like alloy offered by some suppliers) is a perfectly adequate and less expensive material on which to learn the craft.

Etching grounds are either hard or soft. The hard ground is the standard one for line etching, while the soft ground* creates different, particular surface effects. Both are available in solid cake form, and are melted onto the plate

and spread with a dabber or roller. Alternatively, a liquid hard ground can be used. Stopping-out varnish is an acid-resistant liquid applied to reinforce the ground in areas not to be etched – or to cover up exposed metal.

The etching needle is a smooth, lightweight metal point. It should not be too sharp, as it is important that it does not scratch the metal as you draw into the ground. It is advisable to obtain a purpose-made tool, but you can

improvise with a darning needle attached firmly to a pen or brush handle. The type and strength of acid solution, or mordant, depends on the metal being used and the intensity of the corrosive effect* required.

Further materials and equipment are needed for the aquatint process* and for printing the plate, but the basic method of printing* for all intaglio images is the same. If you use a professionally equipped etching studio, either for commercial hire or as part of an educational institution, it will have all the facilities you need for any of the techniques described here.

FURTHER INFORMATION

* Biting the plate, pages 92–93
* Aquatint, pages 94–95
* Soft ground etching, pages 96–97
* Intaglio printing, pages 102–109

6

10

11

PREPARING THE PLATE

The intaglio (sunken) areas of an etching plate can be quite deep, in some cases both deep and narrow, and so the print has to be taken under heavy pressure. Because the paper is forced into the sunken areas it becomes embossed to some extent, as well as picking up the ink. If the plate has hard, vertical edges, these can cut through the paper under pressure, even though the thickness of the metal is no more than 2–4mm ($\frac{1}{16}$–$\frac{1}{8}$ in). To avoid damage to the paper and the soft blankets that help to spread the pressure of the press rollers, the edges of the plate are bevelled to an angle of about 45 degrees by rubbing them down with a file. This is usually done as a preliminary process, although edges can also be filed and polished immediately prior to printing.

Before laying the acid-resistant ground the surface must be clean and completely free of grease, otherwise the ground may adhere imperfectly and cause the effect known as "foul-biting" in the acid, when blemishes allow non-printing areas of the plate to become mildly and irregularly corroded.

Bevelling the plate
1 Position the plate so that it is firmly supported but one edge just protrudes from the edge of the work surface. File all along the edge, keeping the file at an angle of 45 degrees. Repeat on all sides of the plate.

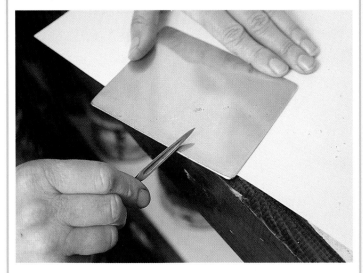

2 To smooth any marks that the file has left, you can work along the bevelled edges with a scraper, held at the same angle. Shave the metal lightly with the scraper blade.

3 You can leave mitred corners or, if you prefer, round them off completely. Because intaglio prints have a slightly embossed effect, the edges of the plate do leave a clear impression on the paper, so they should be even and clean.

Degreasing
1 Put a small heap of French chalk or whiting on the plate and pour in a few drops of household ammonia.

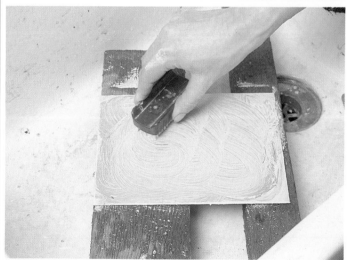

2 Work the ammonia and chalk into a paste and rub it across the whole plate surface, using a lightweight scrubbing brush, cotton wool or a soft rag.

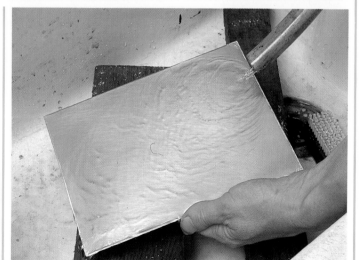

3 Rinse off the plate with clean water. If it is completely degreased, the water will flow evenly across the surface. If the water runs around remaining grease spots, repeat the process. Then dry off the plate.

APPLYING HARD GROUND

The ground must be applied evenly to form an effective acid-resistant coating that is durable but can be lifted easily and cleanly as you draw into it with the etching needle. The solid ball of hard ground as you buy it from the supplier is shiny and brown-black. The basic ingredients are bitumen, wax and rosin (colophony), but there are various recipes and some etchers prefer to make their own. It is applied to a warmed plate, heated gently on a hotplate. Dabs of ground melt onto the surface of the metal and are rolled out in all directions to form a smooth, thin coating. The completed ground is a warm, golden-brown colour.

It is important not to "overcook" the ground, as too much heat causes it first to slide on the surface, then to coagulate and stick to the applicator so that the coating becomes lumpy and uneven. If this happens, cool the plate, clean it off and start again. Getting the right touch in grounding a plate is a matter of practice; for instance, you may find a forward pass of the roller lays down the coating, and a quick backward roll lifts any excess.

Smoking

Smoking the ground with tapers, which hardens it slightly and turns it a darker colour, is not essential, but it does make it easier to see the marks of your drawing with the needle. Wax tapers are used, which give off a dark smoke that deposits carbon on the ground. Only the smoky trail from the tapers, not the naked flame, should touch the ground, which turns black and shiny as it carbonizes. Using the centre of the flame can scorch the ground, and it will begin to flake.

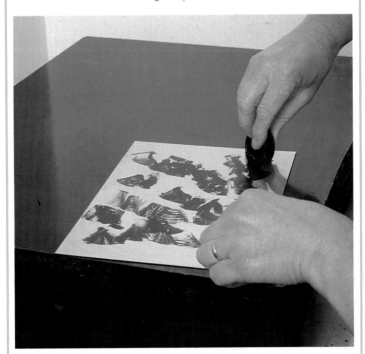

Applying hard ground
1 Put the degreased plate on the hotplate and let it warm through. Dab the ball of hard ground onto the surface, allowing it to melt into random smears.

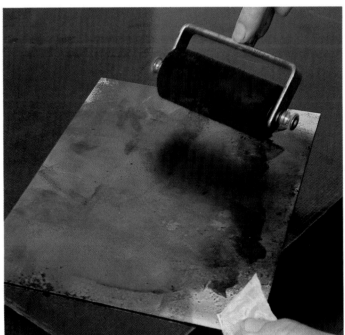

2 Use a hard-wearing roller to spread the ground evenly across the plate, working in all directions.

3 Continue to work with the roller, travelling from side to side both ways on the plate until the ground is thin and even, and a uniform golden-brown colour.

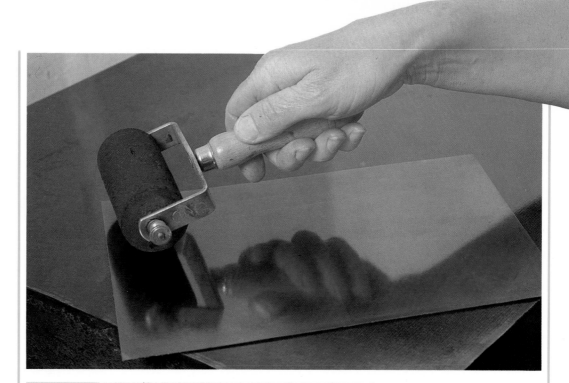

Smoking the ground

Secure the plate at one edge in a pair of pliers or hand-held clamp. Put a small fold of paper at the edge to prevent the tool marking the plate surface. Light three or four tapers twisted together to make a long flame. Move the flame under the plate in a circling motion, so that only the smoke trail from the tapers touches the ground. Continue until the ground darkens all over.

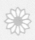

DRAWING ON THE PLATE

Once the ground has been smoked and allowed to cool you are ready to start drawing. If you wish to put down guidelines, you can draw on the ground with a soft, blunted pencil or trace down your design using transfer paper. However, the point of any print process is to exploit the characteristics of the materials and methods, so don't try to copy a preparatory drawing too slavishly – let the composition evolve freely on the plate.

You can manipulate the etching needle in just the same ways as you would a pencil or pen. The important thing to remember is that it need only lift the ground – it is actually a disadvantage if it scratches into the metal – so do not apply too much pressure. The work of cutting into the metal is all done by the acid, and if your lines are unevenly scored into the plate, this will affect the quality of the acid bite. You do need to expose the plate cleanly, however; if you can still see a thin brown film across the line the ground is not fully removed.

You will gradually get used to the effects of etching and learn the best ways to draw up your image. A very broad line will bite as a shallow furrow in the metal, and because of the surface quality of the intaglio and the method of inking and wiping the plate for printing, this will print paler at the centre than at the edges. In hatched areas where lines are close together the acid may break through the tiny sections of ground dividing them. If you wish to begin with fairly even, black line work, keep the drawing relatively fine and the textures clean and distinct.

Stopping out
Before etching, every part of the plate surface that is not deliberately exposed as part of the image to be etched must be completely protected by an acid-resistant covering. This involves painting the back and the bevelled edges of the plate with stopping-out varnish – the plate may have been supplied with a prepared acid-resist backing, but the edges must still be stopped out.

On the front of the plate, any part of the ground where there is no drawing can be covered with varnish to prevent foul-biting. You can also use stopping-out varnish to refine lines scratched too coarsely in the ground or to cover errors.

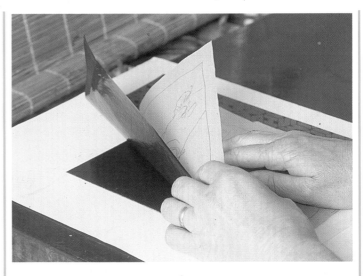

Drawing on the plate
1 If you are transferring an existing design to the plate, cover it with transfer or carbon paper and lay a trace of your drawing on top.

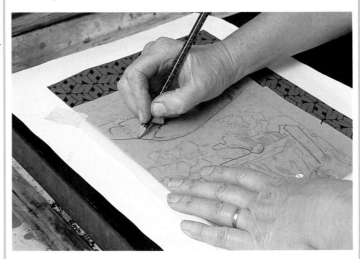

2 Tape down one edge of the trace so that it is anchored in position. Go over the drawing with a pencil so the transfer paper lays down the lines on the ground beneath.

3 Draw directly into the ground with an etching needle as freely as you would draw on paper with a pencil. Avoid scratching into the surface of the metal. The lines you make should just lift the ground cleanly.

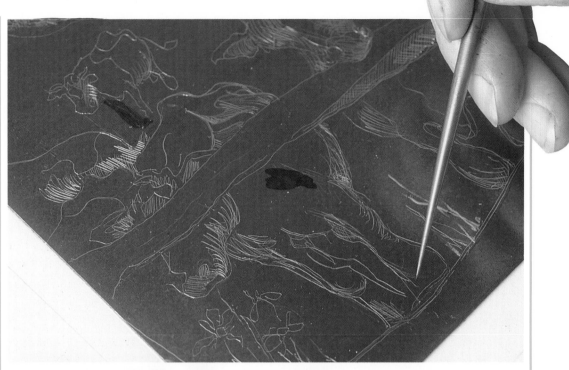

Alternative tools
1 You can use other implements to work into the ground. An ordinary dip pen makes calligraphic, double lines because of the split in the nib.

2 A small roulette – this is a dentist's drill bit – rolled over the ground makes a lightly toothed linear pattern.

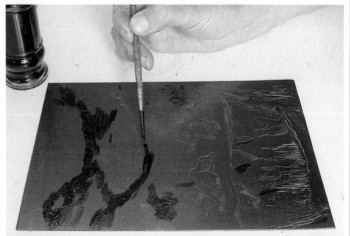

Stopping out
When the drawing on the ground is complete, paint stopping out varnish over any non-printing areas where the ground is imperfect. Finally, stop out the edges and back of the plate as necessary, so no bare metal will be exposed to the acid except in the drawing.

BITING THE PLATE

The action of acid on metal is called the "bite". One of the difficulties for the beginner is that there are no simple rules for estimating how long the plate needs to be in the acid bath. The speed and strength of the bite varies according to a number of factors – the types of metal and acid used, the extent of plate surface exposed to acid, the temperature of the acid bath and that of the studio environment. You also have to consider the effect you wish to achieve – whether the lines should be fine and shallow-bitten or deep and strong. This is all learned by experience, but even so it remains a relatively unpredictable technique.

A plate can be bitten in stages to produce different line qualities. All the lines are bitten for a certain length of time, then the plate is removed from the acid, rinsed and dried, the fine lines are covered with stopping-out varnish and the plate is returned to the acid to etch the remaining lines more deeply. A detailed image may require many different stages of grounding and biting. It is difficult, though not impossible, to rework bitten lines cleanly through a new ground. The addition of tone and texture may, however, alter the effect of the initial line work, and decisions about reworking can be made on the basis of proofs pulled at different stages.

The acid bath

The bath to contain the acid solution can be a glass, porcelain or plastic dish or tray – obviously the material must not be susceptible to the corrosive effect. Ideally it should be sited under an extractor hood; at the least it must stand in a well-ventilated part of the studio. When checking a plate in the acid, do not stand over the bath for too long, because you will be breathing in fumes.

It is essential to work carefully and steadily when handling acid bottles and mixing solutions. Preferably this will be done for you by an experienced tutor or technician. Acid and water generate heat when combined, so to control this, the acid must be added to the water, never vice versa. The solution for the acid bath, which varies from a 1:1 ratio to about 10:1 water to acid, depending upon the purpose, is safer to work with than full-strength acid, but you should still take precautions like wearing rubber gloves, and if any of the solution splashes on your skin, rinse it off with clean water.

For copper and zinc plates, nitric acid can be used. The solution is made slightly stronger for copper, which bites slowly, and the reaction with the metal gradually turns the acid blue. On zinc, the acid bites quite quickly and produces bubbles on the plate surface. These must be removed with a soft brush or feather; otherwise the bubbles form a sort of acid-resist and the result is a textured bite.

Two other solutions commonly used are Dutch mordant for copper – a mixture of hydrochloric acid, potassium chlorate and water – and ferric chloride, used for copper or zinc. Be sure to get professional advice on the type of mordant to use and its strength for the job in hand.

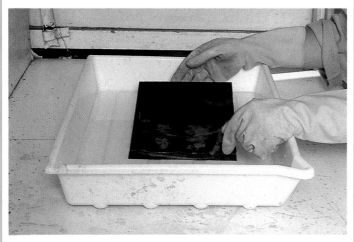

Biting the plate
1 Lower the plate gently into the acid bath. In the parts of this process when your fingers are likely to be in contact with the acid, it is wise to wear rubber gloves.

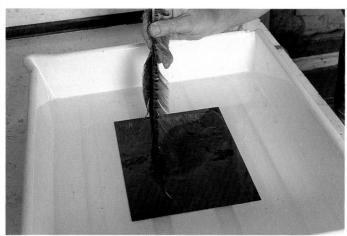

2 As the acid begins to act on the metal, you will see bubbles forming on the plate. Brush them away gently with a feather.

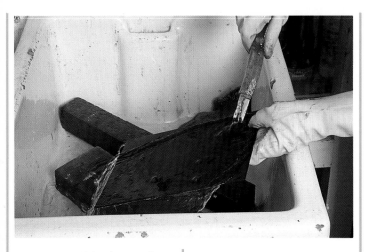

3 When the biting is complete, remove the plate from the acid, transfer it to the sink, and wash it off with clean running water.

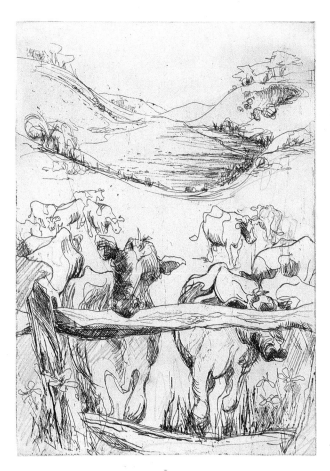

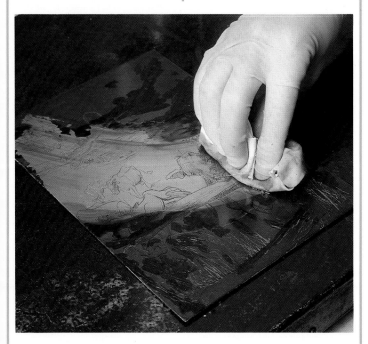

4 Return the plate to the work surface and wipe off the ground and stopping out varnish with white spirit. When the plate is completely clean, you are ready to take a first-stage proof.

5 A line etching reflects the vitality of your drawing and at the same time contributes qualities of its own – particularly the richness of the black line, due to the amount of ink held in the intaglio. You can produce finished etchings in line work only. This example will be given more overall tone with the addition of aquatint (see overleaf).

AQUATINT

This process enables you to create both areas of solid tone on an etching plate and gradations of tone from white through a range of greys to black. It is commonly combined with line etching to give weight and modelling to the image, but can be used as the primary technique.

Aquatint involves laying a coating of resin dust on the plate, which is then heated, causing the resin to melt into tiny globules. On removal from the heat, these harden and when the plate is etched the acid eats into the pits between the globules to produce a fine, all-over intaglio texture. Tonal variations are made by successive stages of stopping out areas of the plate and biting the exposed shapes in the acid, gradually etching the pitted surface more deeply. To check the tones, the resin must be removed with solvent before proofing the plate, so you cannot rebite into the same texture after proofing.

Areas which are too dark can be retrieved by burnishing, although this affects the texture. You can also use aquatint as a dark-to-light method, like mezzotint, by biting a continuous dark tone over the whole plate and working into it with a scraper and burnisher.

Applying aquatint resin

There are several ways of doing this, and the choice will depend on the facilities available and the textural effect you wish to produce. A dense, even aquatint tone is best achieved by using a purpose-designed aquatint box. This is fitted with bellows or a revolving paddle worked from outside, with which you agitate the resin dust in the box so that it flies up in a dense cloud. The plate is then inserted face up and the dust allowed to settle on it.

The alternative is to apply the resin direct to the plate with some kind of shaker. Various devices can be used – a muslin bag; a salt shaker; a jar with muslin stretched across the top; a fine sieve. The more random and uncontrollable the fall of resin from the shaker, the more irregular the aquatint texture. A rough aquatint can

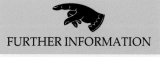

Applying aquatint resin
1 The easiest and most reliable way to lay aquatint is in a purpose-made box, fitted with a revolving paddle. The box contains a large amount of resin which, when the box is not in use, settles in the bottom of the drum (see diagram).

be effective in prints that incorporate textural variety, but if you are looking for subtle tonal gradations, the resin must be finely and evenly laid.

Biting an aquatint

Appreciable variations of tone occur in minutes, even seconds, as you go through successive bitings. At the first stage, you stop out* the areas of the plate to remain white, and also cover the back and edges of the plate with varnish. The acid solution should not be too strong, or it may eat sideways under the resin rather than etching down evenly into the pitted texture. After the first biting remove the plate from the acid, rinse and dry it. Then stop out the next lightest tone and return the plate briefly to the acid.

This process is continued until you have as many tones as you require. The

accumulated time that the plate is in the acid may be less than an hour over all, but you need time in between for stopping out. The varnish must cover the aquatint grain thickly and cleanly and be allowed to dry completely before the plate is rebitten. Be careful not to leave the plate too long in the acid on the final bite, or it may break down the resin ground, resulting in a foul-bitten, irregular texture.

If you have begun with line etching, your line work will provide a guide for laying in the aquatint tones. If you are working direct onto aquatint ground, you can trace down a layout using transfer paper.

FURTHER INFORMATION

* Stopping out, page 91

A: stirring up resin dust

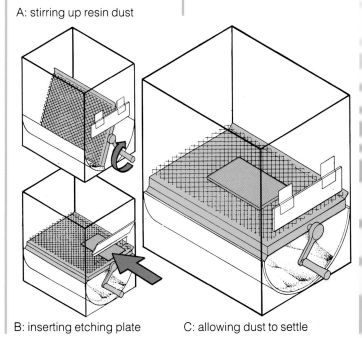

B: inserting etching plate C: allowing dust to settle

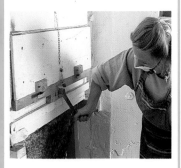

2 Close up the front of the box and turn the handle vigorously. This turns the paddle which agitates the resin dust and causes it to fly up inside the drum (see diagram A).

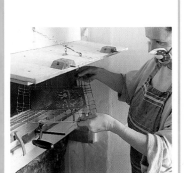

3 Lock the handle in the position where it keeps the interior paddle horizontal. Put your etching plate on a wire tray and insert it in the box. A face mask prevents you from inhaling any dust that drifts out. Close up the front of the box again (see diagram B).

4 After a few minutes, check that an even coating of resin has fallen onto the plate (see diagram C), then remove the plate from the tray and transfer it to a metal grid. Use a small blowtorch or Bunsen burner to heat the plate from underneath.

5 Keep the heat source moving gently underneath the plate so that it does not scorch the resin. The whitish, powdery coating gradually melts and turns yellow. When this colour has spread right across the plate, allow it to cool.

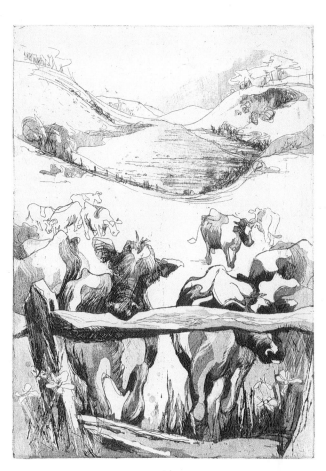

Aquatint tones
You can stop out areas of the design and return the plate to the acid several times to produce a range of tones, but overbiting may break down the aquatint. In this example, there are three greys – pale, mid-toned and dark, and the heavier black. Pale grey might require only seconds in the acid, black several minutes in all. The tonal modelling can considerably alter the character of the print – compare this version with the line etching on page 93.

SOFT-GROUND ETCHING

Soft ground is similar in composition to hard ground but has a higher grease content that contributes the softer texture. It is applied to the plate in the same way as hard ground*, using a roller or dabber to spread the coating evenly and thinly. A soft ground is not smoked.

You can draw directly into soft ground with an etching needle to produce a line drawing with a softer, less precise character than that typical of work on hard ground. However, where soft ground really comes into its own is in using techniques that depend upon making an impression in the ground. Because the coating is soft and tacky, it is picked up by any material pressed down hard against it. You can draw through a piece of paper onto the ground to produce a line quality resembling soft pencil or crayon marks. All sorts of found materials leave a clear impression that etches quite accurately – woven fabrics, yarns and meshes, feathers, thin wood-grain. To make the impression, the material is laid on the plate, covered with a clean sheet of paper and rolled through the press.

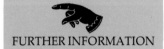

FURTHER INFORMATION

* Applying hard ground, pages 88–89

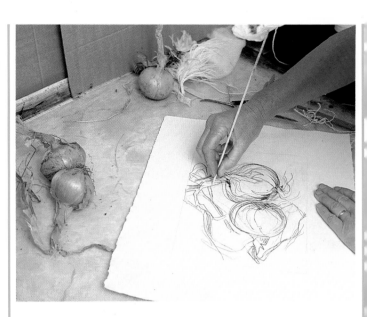

2 Use a hard but not sharp point to impress on the paper. Here the artist is working with a plastic knitting needle.

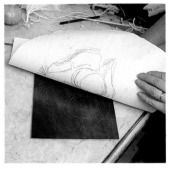

3 At any stage of the drawing you can lift the paper to check the impression on the plate, but be sure to keep one side of the paper firmly anchored, so it goes back down in exactly the same place.

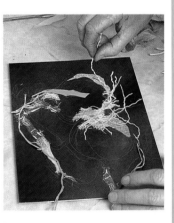

4 When using found materials to create soft ground textures, simply lay the pieces on the plate in the appropriate position.

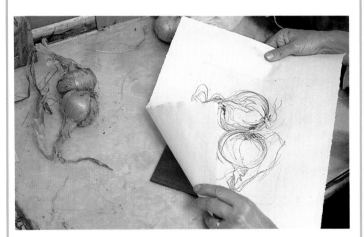

Soft-ground textures
1 To make a drawing on soft ground, either work direct onto a clean piece of paper laid over the plate, or make a master drawing beforehand that you can trace over.

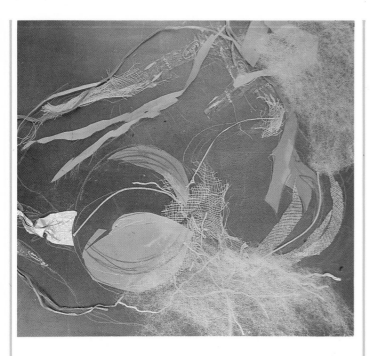

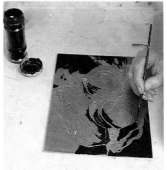

8 Stop out any non-printing areas of the plate and protect the back and edges as necessary. You can now etch the plate in acid – keep checking the action of the acid bite, so that fragile textures do not break down.

5 It is worth experimenting with all kinds of materials – some textures "take" better than others. This example shows tracing paper, scrim, Cellophane, string, ribbon, wadding and dried leaves from the onions that are the subject of the print.

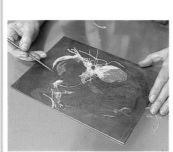

6 Move the plate to the bed of the press and cover it with a clean sheet of paper. Run it through the press so that the pressure embeds the materials firmly in the ground.

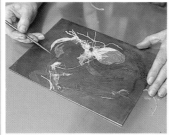

7 Lift the materials from the plate very carefully, without actually touching the ground. You can pick up paper or fibrous materials with an etching needle, or catch one end with tweezers.

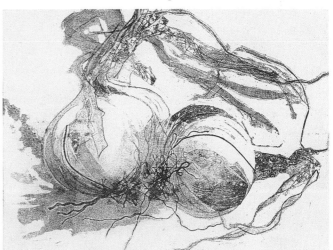

9 The final result of this print is a very pleasing combination of tones and textures. Although the materials were quite randomly chosen, they suit the subject well and the contrast of soft lines and tonal masses gives the image weight and depth.

SUGAR-LIFT PROCESS

This process is generally associated with aquatint, but can also be used to expose areas of the plate for open biting. (This term simply means exposing a broad area of the plate surface to acid, as compared to line work or the grainy texture of aquatint.) Usually, when you use stopping-out varnish to protect unexposed areas, you are painting it on as a negative surround to the shapes that will be bitten. The sugar-lift process is a resist technique that enables you to etch any shape that you have painted positively, from a solid, flat area to a textured brushmark.

You paint your design on the plate with a sugar solution coloured with ink or gouache, allow it to dry, and cover it with diluted stopping-out varnish or liquid hard ground. You then immerse the plate in warm water, and the sugar gradually dissolves and lifts the varnish, leaving the acid-resistant coating in place around the painted marks. You can then aquatint the exposed areas or etch them as they are.

Sugar-lift process
1 Paint your design with the sugar solution on a clean, degreased plate. The solution used here was one part sugar to four parts water and one part ink. Heat the water to dissolve the sugar grains.

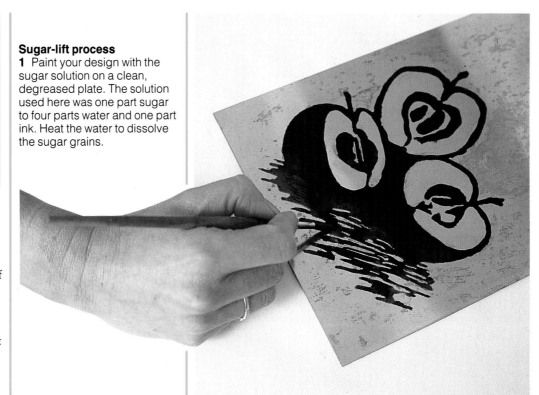

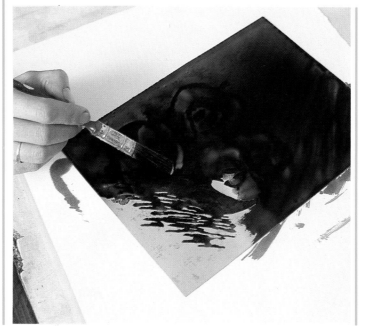

2 Allow the sugar painting to dry completely – this can take some time, especially if the atmosphere is humid as the sugar reabsorbs moisture. When dry, cover the whole plate with a thin coat of stopping out varnish diluted with white spirit.

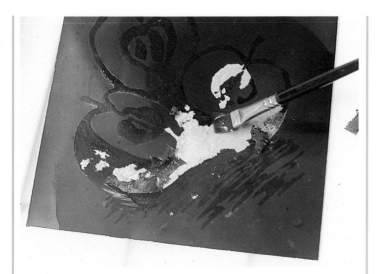

3 When the stopping-out varnish has dried, immerse the plate in a bath of water. Leave it until the sugar begins to dissolve and the varnish lifts.

Then you can brush it lightly to assist the process.

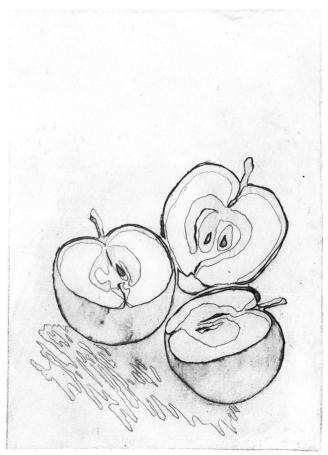

4 When the sugar coating has all lifted, leaving the design exposed in the varnish layer, place it in acid to bite as required (you can apply aquatint over the varnish if preferred). This plate is open biting – the bubbles show the fast action of the acid on the exposed metal.

5 The resist technique retains the fluid, calligraphic quality of the original painting. Open biting typically produces the strong outlines visible in this print, especially if the plate is etched quite deeply. After the first bite, parts of the image were stopped out and the plate returned to the acid for further biting, which produced the darker tones in the outlines and small shapes.

ETCHED TEXTURES

Etching provides a far greater range of surface effects than any other intaglio process. All the techniques previously described can be combined on one plate, and there is plenty of room for experiment. For example, stopping-out varnish floated onto water breaks up into fascinating marbled textures that can be transferred to the metal simply by holding the plate face down on the water surface. There are also many variations that can be obtained using different materials to impress a soft ground, or by applying stopping-out varnish to a clean plate using standard painting techniques such as dry brushing and spattering. The strength and depth of the acid bite can also be exploited to vary tone and detail.

You need to plan carefully so that your composition does not become overloaded with busy textures, but since the marks that result from different processes are all etched into a single surface, they generally cohere very well when printed.

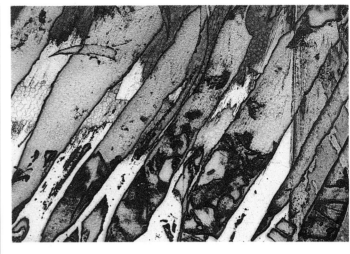

Marbling
Stopping-out varnish floated on water picks up on the surface of the plate and etches into this rich, random pattern. The striped effect is caused by open biting between strips painted with stopping out varnish. The white areas represent the unetched plate surface.

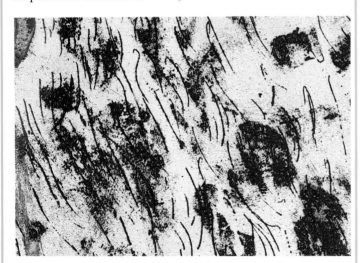

Drawing and impressing
The lines were drawn in the hard ground with free, quick strokes of the etching needle. The rounded smudges are fingerprints, made by pressing on the ground with a fingertip dampened with white spirit.

Rough open bite
This fully exposed area of the plate was left in the acid for a long period. The bubbles building up on the metal due to the action of the acid gradually formed a resist; the bite worked around the bubbles to produce this pebbly texture.

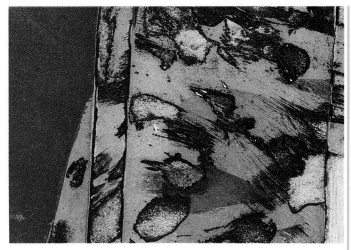

Combined textures
The grid is composed of lines ruled in hard ground, the smoother tonal areas are shallow open biting applied to areas exposed by wiping the ground with white spirit on a rag. The scumbled texture was rubbed into the ground with wire wool. The "bird's wing" detail was made by drybrushing into the ground with a brush dipped in white spirit; the resulting marks were allowed to etch a long time without feathering.

Open bite and aquatint
The spotted pattern was formed by spattering white spirit onto hard ground and blotting with a rag. The dark background is aquatinting; the orange colour a coating of ink rolled over the plate surface.

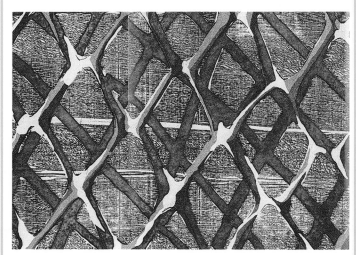

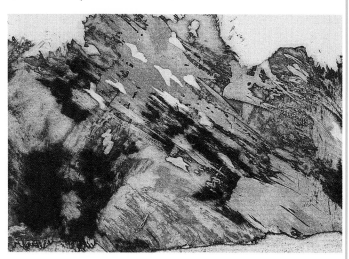

Soft ground and aquatint
The wood-grain effect was achieved by impressing a thin wood veneer into soft ground. The criss-cross wire pattern was fully stopped out while the wood texture was etched, and was later aquatinted to achieve the tonal variations.

Etching and drypoint
Various areas of etched open bite and linear textures produced an interestingly atmospheric print, but lacked strong contrast. The darkest tone was supplied by raising a burr with a drypoint needle on the zinc plate.

INTAGLIO PRINTING

PREPARING PAPER

INKING AND WIPING

TAKING THE PRINT

COLOUR PRINTING

(This chapter shows how to print the intaglio methods of drypoint, mezzotint and etching.)

The method of printing from an intaglio plate is essentially the same for all processes – drypoint, engraving, mezzotint and etching. Unlike block printing or lithography, when it is strictly surface contact that forms the impression, the pressure of printing must force the paper into the intaglio to pick up an even impression from marks as varied as fine creviced lines, delicate aquatinting and deep, open bite. The way the paper is pushed into the lines and sunken areas in the plate produces an embossed effect that adds an extra dimension to the print.

A flat-bed press is used, consisting of a heavy metal bed that passes between two large rollers. Studio presses are usually very heavy and work on a gearing system that makes it easier to move the weight of the bed, operated by turning a large wheel at one side. The space between the rollers can be varied to alter the pressure. Soft felt blankets, which cushion the rollers and spread the pressure evenly, are used to cover the plate and bed before they are pressed through the rollers.

Equipment for intaglio printing
1 Glass mixing slab; **2** tube intaglio ink; **3** palette knife; **4** coarse and fine wiping canvas (scrim); **5** tinned intaglio ink; **6** powder pigment; **7** copperplate oil; **8** blotting paper and tissue; **9** rollers.

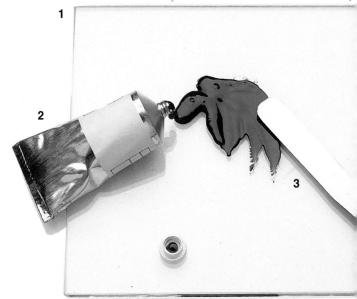

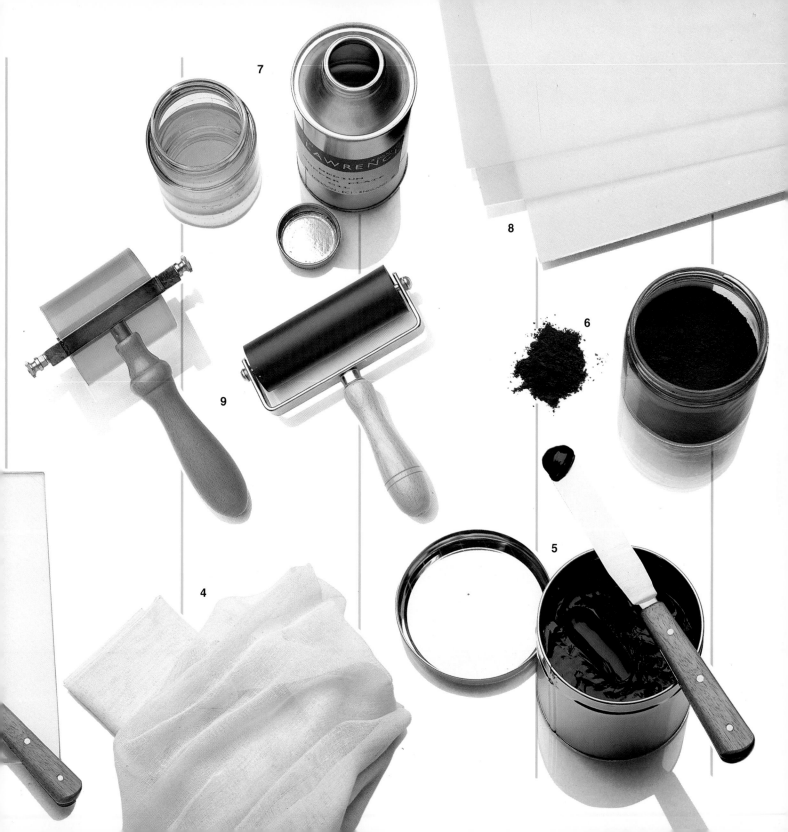

PREPARING PAPER

Intaglio plates are printed on damp paper, which gives more flexibility for pressing into the intaglio without the paper splitting or failing to pick up all the ink. The paper is prepared beforehand by soaking in clean water. It is then drained and blotted, interleaved with blotting paper, pressed between boards, and left until needed.

High-quality watercolour papers are often chosen for intaglio printing, particularly hand-made or mould-made papers with deckle edges which look good when framed without a mount. It is important that the weight and texture of the paper suits the style and complexity of the image, so that fine marks are picked up accurately where appropriate and the qualities of the print do not compete with that of the printing surface.

Preparing paper
1 Put the paper to soak in a bath of clean water. The amount of time it needs to soak depends on the weight and texture of the paper – it must become fully damp right through the fibres.

2 Lift the paper from the water bath and let it drain. Lay it on a sheet of blotting paper and cover it with a second sheet. You can build up a stack of paper layers in this way. Lay a board on top to press it so the paper sheets remain flat and moist.

INKING AND WIPING

Before you start to take a print, make sure the plate is completely clean and free of any traces of ground or varnish. Check that the edges are cleanly bevelled; if they have been damaged during the etching process, file them smooth again.

The inking process requires a heavy first application of ink, which must be rubbed well into the plate so that it is pushed into all the intaglio marks. The plate is then wiped carefully and thoroughly to take off all surplus colour. This is easiest to do if the plate is warmed slightly on a hotplate, but heating is not always essential. It is important that there is no "loose" ink left on the surface after wiping, as this will prevent the true tones of the intaglio being seen, and make it impossible to produce identical prints.

Although ready mixed inks are available, many printmakers like to mix up inks from powder pigments and copperplate oil. Selecting particular types of pigments, even different kinds of black, gives them control over the tones and colours of the print as well as the consistency of the ink, which can vary from a rich liquid to a thick paste.

The ink can be applied with

a ready-made dabber or simply with a pad of coarse muslin, called scrim or tarlatan. The same muslin is used for wiping, with a slightly finer fabric sometimes chosen for later stages. The final wipe, which polishes the white areas and cleans the pale tones, is done with the heel of the hand, dusted with French chalk, or with pieces of tissue rubbed flatly over the metal surface. Drypoint plates are not hand-wiped, because the burred texture is abrasive.

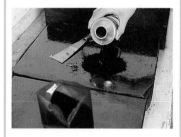

Mixing ink

1 Use a broad palette knife to lay a heap of powder pigment on the mixing slab. Make a depression in the centre and pour in a small pool of copperplate oil.

2 Push the pigment into the oil from all sides and start to work it into a paste, alternately pressing and lifting the mixture with the knife. Continue until the ink has a smooth consistency. The amount of oil you add determines whether it is stiff or fluid.

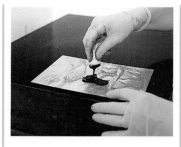

Inking the plate

1 Let the clean etching plate warm through on the hotplate. Twist a small piece of wiping canvas (scrim) to make a dabber – a little firm pad with a "stalk" that you can hold it by. Pick up ink on the pad and dab it on to the plate.

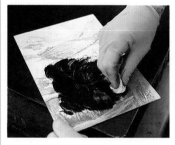

2 Work the ink into the intaglio all over the plate surface. Use a generous amount of colour, and push it firmly into any deep lines and heavily bitten areas.

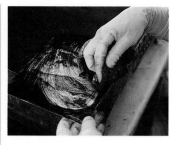

3 Fold a large piece of wiping canvas into a pad and briskly wipe the surface to remove excess ink. Keep the pad travelling flatly across the plate to clean the smoother textures and lighter tones – do not dig the ink out of the deep intaglio.

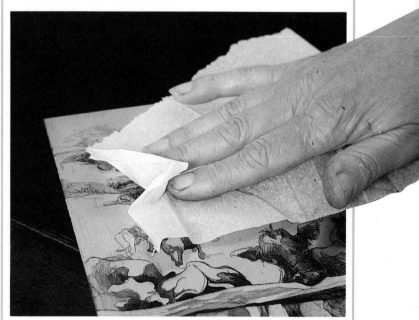

4 When you can see the design clearly, continue wiping with a clean piece of canvas, working lightly and consistently so no obvious smears of ink are left on the surface.

To polish the light tones and obtain a clean tonal range from the aquatint areas, go over the plate with a piece of tissue. Spread your fingers flatly on the tissue and rub with a circular motion.

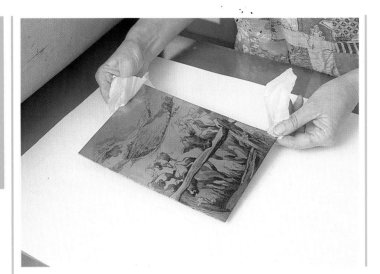

TAKING THE PRINT

This process is very simple. The plate is positioned on the flat bed of the press and the damp paper laid over the top. The felt blankets are spread over them, between two and five layers, with a lightweight felt next to the plate and a heavy, napped blanket next to the press roller. The handle of the press is turned to run the bed between the rollers.

To make sure that the impression is taken square on the paper, with even borders, you can lay a base sheet of paper on the bed of the press with the outline of the plate marked on it. When the printing paper is placed on the plate, the edges can be aligned to the base sheet, working from one corner. Alternatively, you can stick masking-tape guides for both plate and paper onto the bed of the press.

Taking a print

1 Make sure the blankets are in place on the press, fed in under the roller but turned back so the bed of the press is clear. Lay the inked plate on a clean sheet of paper on the bed.

2 Turn back the board on the paper stack and lift out one sheet of damp paper. To keep the edges clean, hold it between small paper folds.

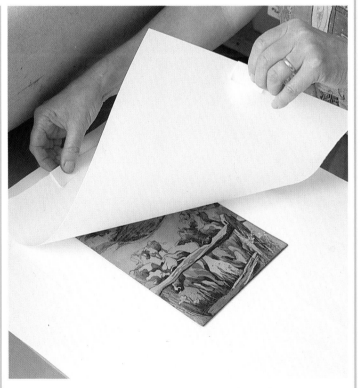

3 Position one corner of the paper on the press in relation to the inked plate. Gently lower the paper and smooth it down on the plate.

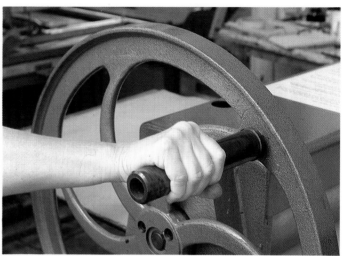

4 Pull the blankets down onto the bed of the press one by one, smoothing them carefully in place over the plate and paper.

5 Turn the handle of the press to pass the bed between the rollers. It should turn easily, though a slightly greater effort is required as the thickness of the plate moves through, as the pressure of the rollers does need to be quite heavy.

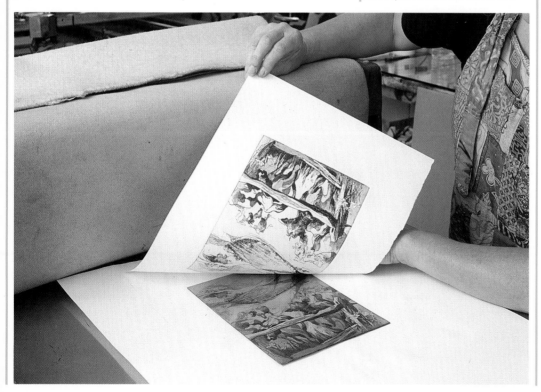

6 Take the bed through far enough to release both the plate and printing paper from beneath the rollers. Turn back the blankets and peel the print up gently from one corner. The finished print is the example shown in full on page 95.

COLOUR PRINTING

There are several ways of introducing colour into an etching, even when you are working on only one plate. One method is to ink up the intaglio in one colour, usually black or a dark colour such as blue or sepia, then use a roller to lay down a flat coating of a second colour over the plate surface. Any areas required to print white can be masked off with paper before the colour roll-up.

You can also ink the intaglio in more than one colour, using separate dabbers for different parts of the plate. This is not absolutely precise, as colour areas will merge or overlap slightly in the process of inking and wiping, but it can produce very expressive and atmospheric results.

A more laborious method, which keeps colour areas quite separate, involves cutting up the plate and inking each piece individually. When you come to print, the pieces are then reassembled like a jigsaw on the bed of the press. The disadvantage is that you are likely to see white lines between the cut pieces on the final impression.

Alternatively, you can overprint separate plates, etched with different parts of the design and inked in different colours. This approach needs careful planning, and you have to register the images accurately, both when preparing the plates and when printing.

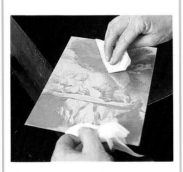

Inking in two colours
1 Warm the clean plate on the hotplate. Make a clean dabber out of wiping canvas and apply your first colour to the appropriate areas. Wipe off the excess.

2 Apply the second colour to the required areas of the plate and wipe off the excess. Wipe again with clean canvas, then finish with tissue as before.

3 You cannot get hard edges to the colour areas working in this way, but both colours appear distinctly, with a gentle transition of mixed tone between them.

Philip Coombs
Window (mezzotint)
This mezzotint image was printed from two plates in separate colours, overprinting one on another. The first plate was light-toned, printed in alizarin crimson; the second, with the image scraped but not burnished into the plate's rocked texture, was inked in Prussian blue and superimposed. The result is a very subtle mergence of the two colours, enhancing the atmospheric character of the print and contributing warm lights.

Judy Martin
Jaguar Turning (etching)
The "duotone" effect of this print comes from inking up the intaglio in black, then rolling over the whole surface with orange. As some of the black ink picks up on the roller, the colour has to be laid in one pass with a roller large enough to cover the whole width of the plate. The bars (detail below) are deep-bitten intaglio burnished down the centre; the irregular white shapes on the animal's body were formed by laying torn paper masks on the plate before the colour roll-up.

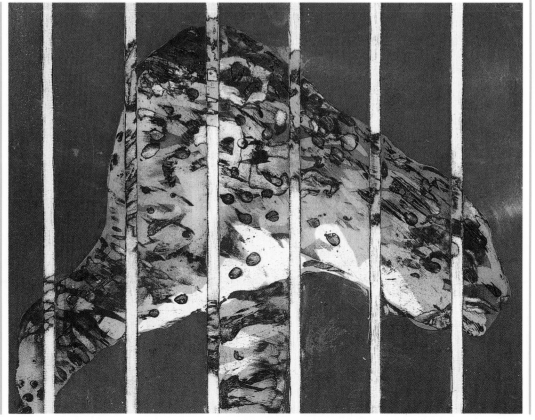

LITHOGRAPHY

PREPARING THE PLATE

PROCESSING THE IMAGE

PRINTING

8

Lithography is in one respect an ideal introduction to printmaking because the image is created by standard drawing and painting techniques, put onto the printing surface in exactly the same way as drawing or painting on paper. You describe the image positively, and the marks you make hold the ink for printing. Monochrome lithographs are comparable in tone and texture to crayon or ink line-and-wash drawings. Colour lithography involves preparing an individual plate for each colour to be printed, but you can build up beautifully wide-ranging effects of surface texture and colour by overprinting.

The process depends on a simple chemical principle – the mutual antipathy of grease and water. The image is drawn with greasy materials on a grease-sensitive surface, with the non-printing areas treated with water-based materials to keep them clean. When printing ink is rolled on, it adheres only to the sensitized, greasy marks. The inked image can be printed on paper either by direct contact or by offsetting, that is, taking up the ink from the plate onto an intermediary surface and laying

3

2

1

it down separately on the paper.

Although lithography is such an expressive, painterly medium, the chemical processing can seem initially tedious and difficult to grasp. However, it is carried out in simple stages, all designed to "set" the image on the lithographic plate.

Tools and materials
Originally, lithographic images were prepared on large blocks of limestone and printed by direct contact. This method is still practised, but it is now more common to use metal plates – zinc or aluminium, depending on which is more easily available. Metal plates can also be printed direct, but are particularly adapted to offset printing. The stone or plate has an even grain which contributes to the characteristic textures of lithographic printing. After printing the surface can be cleaned and resensitized to be used again, but after a few uses it must be completely regrained. There are specialist services for this.

For drawing up the image, you can use litho crayons and pencils, and lithographic ink (tusche), brushed on full-strength or as diluted washes. All these materials are black, but once you have drawn and processed the plate, the image can be inked up in any colour for printing.

The plate is treated with a number of chemicals in the processing stages. The undrawn plate is first sensitized with a liquid preparation known as "counter-etch". Gum arabic is used to protect non-printing areas while you draw on the plate or to seal the plate surface between stages of processing and printing. The image is "fixed" on the plate by applying a caustic etch solution, such as a dilute acid mixed with gum. The term "etch" is confusing if you are already familiar with the physical process of etching* on metal – in lithography the etch solution does not eat into the plate surface; it simply helps to set the greasy marks.

At all stages of processing and printing the plate is frequently dampened and dried off. Sponges are common equipment for lithography, and a hairdryer or fan is essential for drying stages – unless you are prepared to wait hours, or even days, to move on to the next step.

Lithography is essentially a studio-based process, so if you attend a class or work in a commercial studio under supervision, you will find most of what you need already available; ask the tutor or technician whether you are expected to supply any of the materials yourself.

Lithography equipment
1 Lithographic stick ink; **2** lithographic crayons; **3** pencil and graphite sticks; **4** lithographic drawing ink; **5** printing ink; **6** large inking roller; **7** zinc litho plate; **8** expandable sponge.

FURTHER INFORMATION

* Etching, pages 84–101

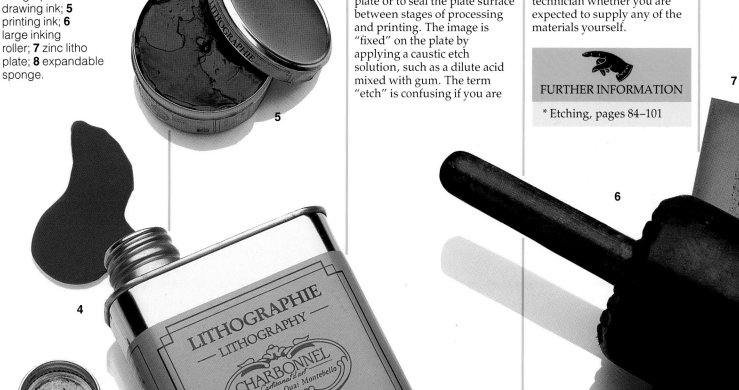

Test plate

Many studios keep printed test sheets that demonstrate various textures you can obtain by using a range of techniques to draw on the plate with lithographic ink and crayon. Other studio materials can also be used, that leave a greasy residue on the plate. The examples shown here are: **1** crayon lines; **2** pen and ink lines; **3** crayon dragged on its side on a textured surface; **4** a solid wash of undiluted litho ink; **5** lithographic pencil lines; **6** wax pencil lines; **7** a wash made with ink floated in water and turpentine; **8** tap-water ink wash; **9** gum arabic resist under oil-based tusche; **10** turpentine wash drawn into with ink; **11** sponged ink; **12** spattered ink; **13** auto-spray paint.

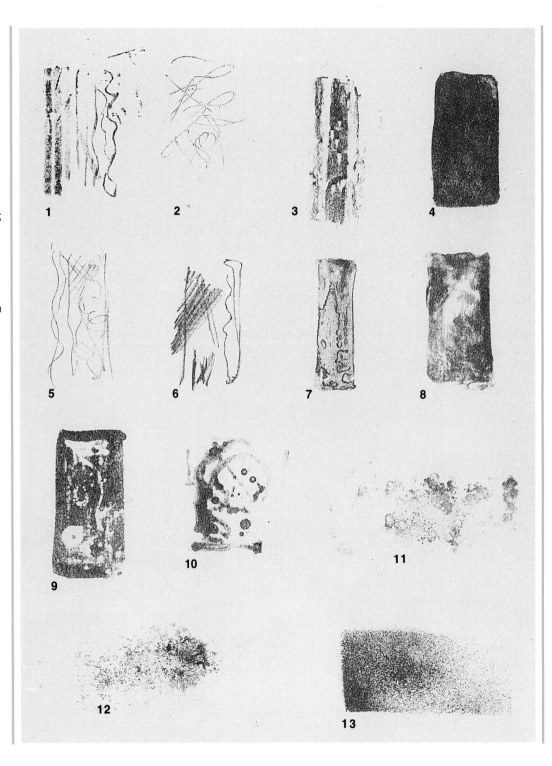

PREPARING THE PLATE

There are a few minor variations possible in the steps and materials applied to preparing and processing a lithographic plate. The demonstration sequence shown here describes a standard series of stages, which explains the basic principles and practice, but you may be taught a slightly different method at the studio where you work.

Initially, once the plate surfaces have been prepared, the artist draws and paints on as many plates as are required for the number of colours to print. A working drawing helps you to identify which details to include on the plate for each colour. To lay out the guidelines of your composition, you can sketch with charcoal or chalk directly on the plate, or trace down over a chalky transfer paper. Remember that the plate is sensitive to any greasy materials (even fingerprints), so pencils or crayons cannot be used for guidelines not intended to appear in the final print.

You can apply the full range of drawing and painting techniques – line drawing with crayon, brush or pen, free liquid washes, sponged, spattered and drybrushed textures. It is also possible to make erasures at this stage to correct any errors. When the plate is fully drawn up, the image is dried, dusted and fixed; then it is covered with a layer of gum and must be left for a while, preferably overnight, before the next stage.

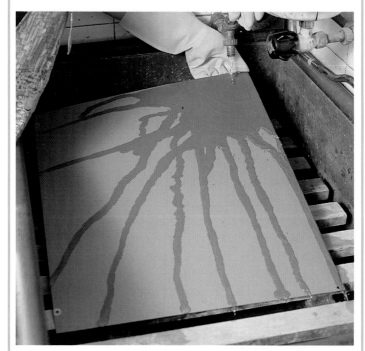

Sensitizing the plate
1 Hold the plate under running water and allow the whole surface to become fully wet. Drain off the excess water but keep the plate damp.

2 Pour on the counter-etch solution and use a sponge to spread it evenly over the whole surface of the plate.

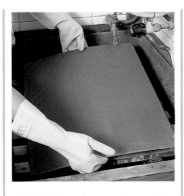

3 Hold the plate under running water and rinse off the solution thoroughly. Drain off the excess water.

4 Dry off the surface of the plate completely. A hairdryer is valuable studio equipment, as the need to dry the plate quickly recurs throughout the lithographic process.

5 Sponge gum arabic around the edges of the plate to make a border for the image area. Allow the gum to dry.

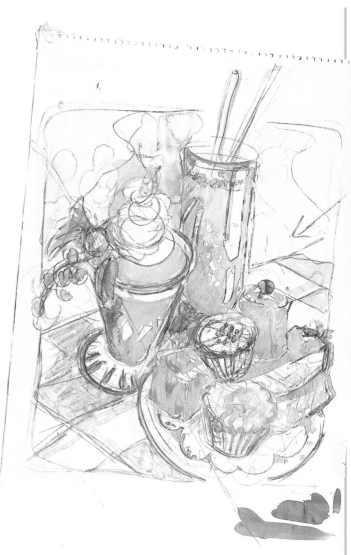

Working study
The lithograph shown in the following demonstration is to print in only two colours, so the artist has prepared her idea of the image quite carefully beforehand in a sketch and more detailed colour study (above). This gives her guidelines for the basic shapes in the composition, the balance of tones and the interaction of line work with broader areas of colour. However, as the image is allowed to develop freely as the plates are prepared, the finished lithograph (see page 123) will be different in character and detail.

Drawing on the plate

1 If you wish to transfer the guidelines of a working drawing to the plate, you must use a non-greasy transfer paper so the lines will not appear after processing of the image.

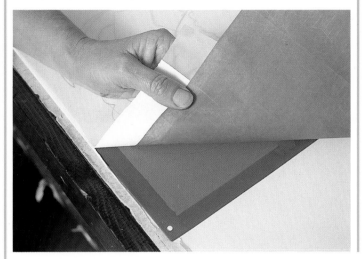

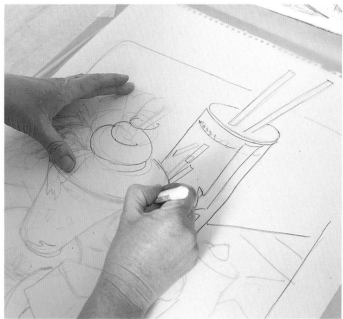

2 Place your drawing over the transfer paper and work over it with a pencil or pen to press down the main lines of the image onto the plate.

3 Start to draw direct on the plate with a lithographic crayon or pencil. You can work exactly as you would with chalk or pencil on paper.

4 Apply the lithographic ink with paintbrushes, again working as you would on paper. You can use the ink at full strength or diluted with distilled or tap water.

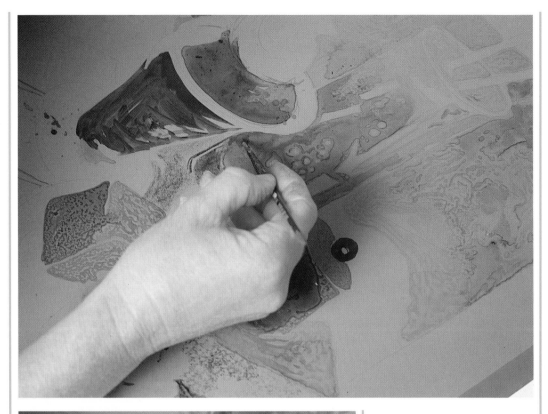

5 You can apply ink with a sponge, as here, or with a rag or other applicator to vary the textures of your drawing. Here, paper masks are used to contain the sponging.

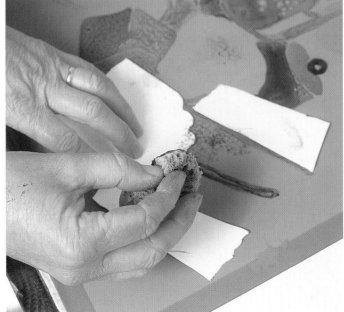

6 Continue until the image is completed in as much detail as you require. Keep in mind that this image will print uniformly as tones of one colour.

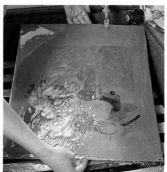

First-stage processing
1 When all the ink drawing is completely dry, dust over the plate with French chalk, spread with clean cotton wool or a soft cloth.

3 Brush on the liquid-etch solution, covering the whole surface of the plate evenly and generously. This helps to "fix" the drawn image on the plate. Leave it on for just a couple of minutes.

4 Put the plate under running water and rinse off the etch solution thoroughly. Use the hairdryer to dry off the plate completely.

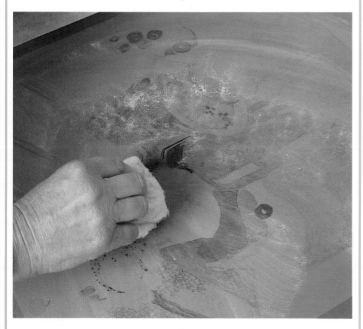

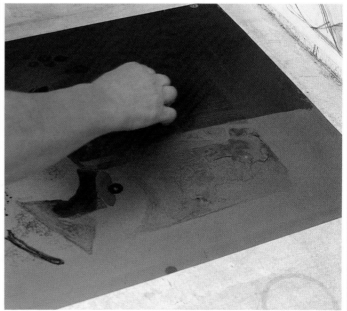

2 Repeat the dusting with powdered resin. These dry materials temporarily counteract the greasiness in the image, so it will accept liquid processing in the next stage.

5 Sponge a thin layer of gum arabic over the whole plate surface and allow it to dry.

Leave the plate overnight before continuing the processing.

PROCESSING
THE IMAGE

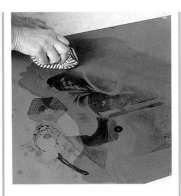

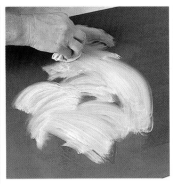

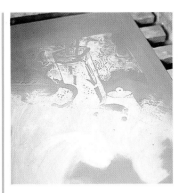

This stage is a second "etch" that strengthens the effect of the greasy marks on the plate surface. It is very similar to the preparatory stages, except that this time the drawn image is washed out and the marks are treated with asphaltum or printing ink. This makes the colour appear different, but as you take out the original drawing and put colour back in you have the opportunity to check how effectively the marks have set into the grain of the plate. This is where you begin to see the real appearance of the image for print and can judge how well the textures have developed. Again there is an opportunity for correction, using an erasing fluid.

When the image is satisfactory, it is rolled up with ink as if for printing, gummed and left to stand. The processing stages are repetitive, but as with any technical methods you will soon become quicker and more expert in seeing them through.

Second-stage processing
1 Use white spirit and a clean rag to wash out the drawn image from the surface of the plate. All the black disappears, but you can still see the marks as a greasy "shadow" on the plate. The gum is unaffected by white spirit and continues to protect undrawn areas of the plate.

2 Rub in a thin layer of printing ink. This helps to reinforce the image and preserves delicate wash effects. Alternatively you can use asphaltum, which strengthens the textures and is better suited to a heavier, more dense drawing.

3 Wipe out the ink with white spirit, then wash off the plate with water to remove the gummed layer still surrounding the image.

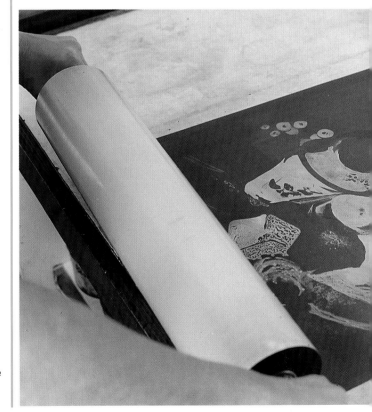

4 Roll up the damp plate with printing ink. The image now appears as it will print. Dry off the plate and cover the surface with gum. Let it stand for at least half an hour.

PRINTING

This sequence demonstrates offset printing in two colours from metal plates. The basic techniques are the same for direct printing from stone or metal, except for the action of the press.

Generally, a litho plate is inked with a large, wide roller that covers the width of the image area in one pass, giving an even, consistent coverage of colour. The difference between lithography and the other processes as far as printing is concerned is that the plate has to be wetted before any ink is applied and kept damp while it is rolled up. The water protects the clean, non-printing areas of the plate but does not affect the ink's adherence to the greasy printing areas.

When the ink layer is dense and even enough to print, the plate must be dried off completely before paper and plate are positioned on the bed of the press. The mechanism of the press brings the thick rubber "blanket" of the roller into contact with the plate on the first pass, and on the way back the roller is pressed over the paper, transferring the inked image. It may take two or three passes to build up sufficient ink on the roller to print off clearly. You can then run your final prints.

When printing in two or more colours, the basic procedure for each one is the same, but you need to register them accurately on the previous printing. There are various ways of registering, but most presses are equipped with grippers and stops that enable you to position the paper correctly in relation to each plate. In this example, the second colour is first printed on an acetate sheet attached to one end of the press. The print of the first colour is positioned underneath the acetate, aligning the colour areas. The stops are then set to the edges of the printing paper so that further prints can simply be slipped into place.

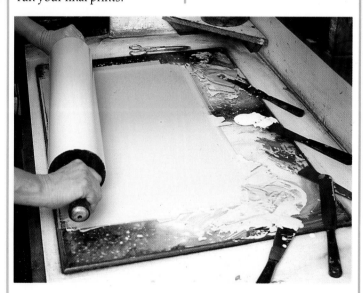

Offset printing
1 Mix up a quantity of printing ink and roll it out evenly on a glass slab. Use a large roller that will cover the image area.

The artist is working here with a gradated tone of pink; she has mixed three tones of the same colour and rolled them out together.

2 Use a wet sponge to remove the gum arabic from the plate. Position the plate on the bed of the offset press. Keep it damp throughout the rolling-up process.

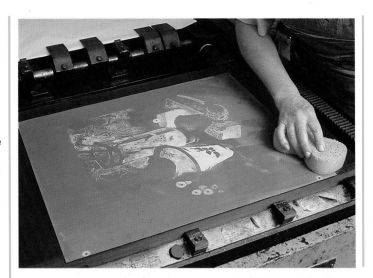

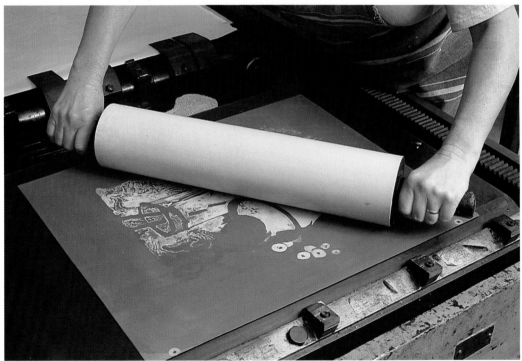

3 Roll the colour over the image area on the plate firmly and evenly. As necessary, wipe the surface with a damp sponge to remove any ink residue that may float on the non-printing surface.

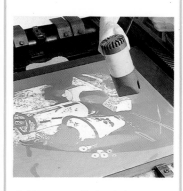

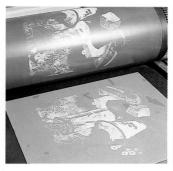

4 When a sufficiently heavy and even colour layer has adhered to the image, dry off the plate completely. If it remains damp, moisture will be picked up on the press roller and spread onto the printing paper.

5 Roll the press roller back and forth over the inked plate until the image is clearly picked up on the roller "blanket" (the rubber covering). Mechanisms for these presses vary; at this stage the roller is not making contact with the area where the paper lies on the press bed.

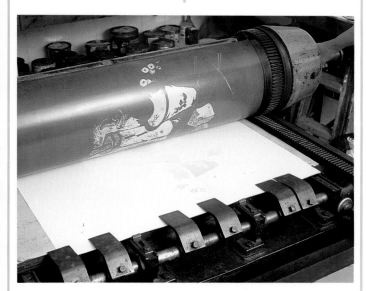

6 Position the paper on the bed of the press adjacent to the plate. The press has grippers to keep the paper flat and in place. Take the roller over the plate and back to pass over and make contact with the paper, laying down the inked image.

7 In the first printing, the main shapes are all in place within the image but the tones and textures are very delicate. The artist has to visualize how the imposition of a second colour will add the depth and detail needed to sharpen and complete the rendering.

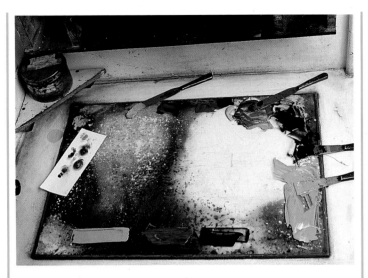

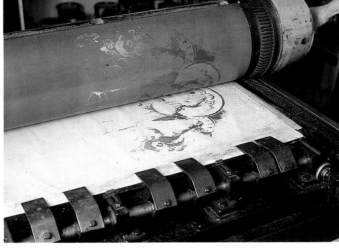

Registering the second colour

1 The artist has planned this print so that both colours are gradated, giving tonal variation across the whole image. She lays out the three mixed tones of the second colour on the mixing slab.

3 The plate is put in place on the press and inked with blue. The first print is taken, by the same technique as previously, on a sheet of acetate anchored at one end of the press.

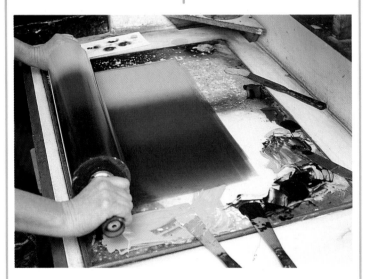

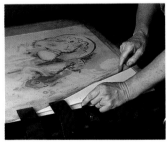

4 A print from the first plate is positioned under the acetate and moved until the image areas register exactly.

2 The large roller is used to work the ink evenly back and forth on the glass slab, until the three colours merge together smoothly.

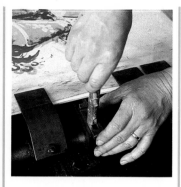

5 Keeping the print in place, the artist adjusts the stops on the press that butt to the side and bottom edges of the printing paper. Methods of registering and marking the position of the paper may vary, depending on the press model.

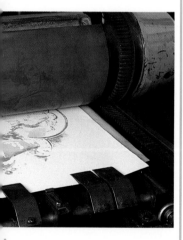

6 The second colour is printed onto each of the pink prints, each time positioning the paper against the fixed stops, and holding it in place with the grippers. As before, the roller is taken across the press over the plate, then back to lay down the blue image on the print.

7 In the final print, the strength of the blue tones emphasizes particular shapes, as does the greater amount of linear drawing included in this image. But the two colours integrate convincingly to give the still life depth and form.

THEMES

❋

LEARNING TO USE A PRINTMAKING MEDIUM CREATIVELY IS A TWO-STAGE PROCESS. FIRST, YOU HAVE TO FIND OUT WHAT IT DOES; THEN YOU HAVE TO SEE HOW THAT POTENTIAL APPLIES TO THE STYLE AND CONTENT OF YOUR WORK. ONE WAY TO LEARN IS BY LOOKING AT FINISHED PRINTS AND UNDERSTANDING HOW THEY HAVE BEEN CONSTRUCTED, IN WHAT WAYS THEY EXPLOIT THE SPECIFIC PROPERTIES OF THE MEDIUM OR EXTEND THEM INVENTIVELY. THIS GALLERY SECTION EXHIBITS A VARIETY OF MEDIA, SUBJECT MATTER AND STYLES OF WORK, AS MUCH AS POSSIBLE RELATED DIRECTLY TO THE TECHNIQUES ALREADY DESCRIBED.

LINE AND TONE

MONOCHROME PRINTS • LINE QUALITIES • SHADING AND LAYERING

Line is a particularly strong element of relief prints and certain intaglio processes, because of the basic techniques in these media and the physical character of the materials used. In monochrome linocuts and woodcuts, where lines form the boundaries of shapes and contribute pattern and detail to the rendering, line qualities are often relied upon to develop visual interest. The quality can vary according to the texture of the relief block – fine line work is difficult on coarse-grained wood or lino, for example. Such practical considerations need to be accommodated when you consider a style of work suited to the subject.

Drypoint is essentially a linear medium, and etching is said to have the most expressive and variable line qualities of all print media, because these derive from both your drawing skills and the action of the acid. However, you rarely see an etching that is completed in line only – more often the line work is combined with smooth aquatint tones, and coarser textures created in a variety of ways.

All of these media also lend themselves to black-and-white renderings, from the strong graphic con-

trast of relief prints to the subtle shadings of aquatint. Since it is always technically possible to include colour, a strictly monochromatic interpretation is the artist's deliberate choice. It can contribute a pleasing simplicity and directness, or a complex, layered and textured effect, like a heavily worked drawing.

Monoprint and lithography are more painterly media, inviting you to exploit the effects of broad areas of tone and colour. Pure line drawing is unusual in a monoprint, and it has to be done with a "broad brush" approach, but the example on this page shows how vigorous and colourful it can be, despite the economy of means. In lithography, the balance of line with mass and texture in a composition is largely a matter of the individual artist's style and the special features of the subject – all kinds of effects associated with crayon or pen drawing and watercolour painting can be achieved, using a limited palette or full colour range. Glorious colour is one of the great pleasures of screenprinting, but this does not preclude the use of linear elements; and tonal balance is an important ingredient of making strong colours work effectively.

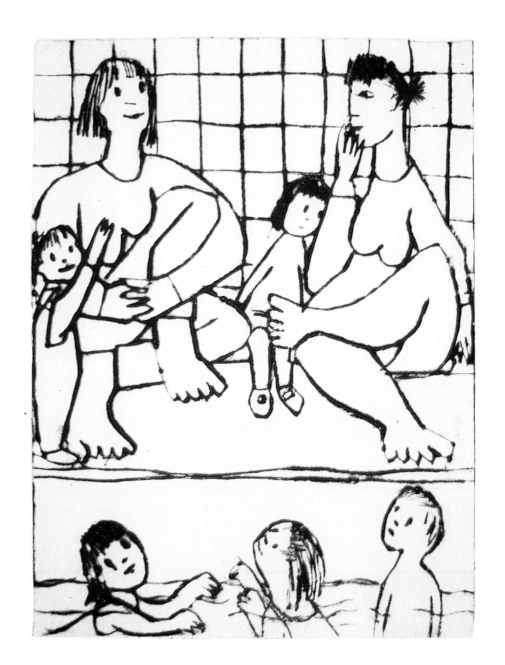

▶ **Anita Klein**
Swimming Lesson (drypoint)
The richly burred texture of drypoint provides a line quality that is both fluid and bold. The artist varies line thickness to emphasize the curving contours of the figures, which are deliberately stylized with a simplicity that is both elegant and playful.

◀ **Carole Katchen**
Embroidered Hat (monoprint)
The printed impression reflects the spontaneity of vigorous brush-drawn lines in this rendering. Their boldness is enhanced by the transition through subtle colour variations that describe different parts of the figure. Open, irregular shapes created by the outline drawing are nicely offset by the repetitive detail of the pattern areas.

Caroline Bilson
St Pancras Station (lithograph)
This print creates such a finely
varied impression of the
architectural detail in the
subject, it is surprising to
discover that the line work is
drawn freely and decisively
with the relatively coarse
medium of lithographic crayon.
To give full impact to the
intricate structure, the colour is
confined to gentle washes of
diluted litho ink, using evenly
matched mid-tones of warm
red and neutral grey. More
emphatic tonal variation occurs
where the washes are
combined with roughly shaded
crayon textures.
● Lithography: preparing the
plate, pages 113–117

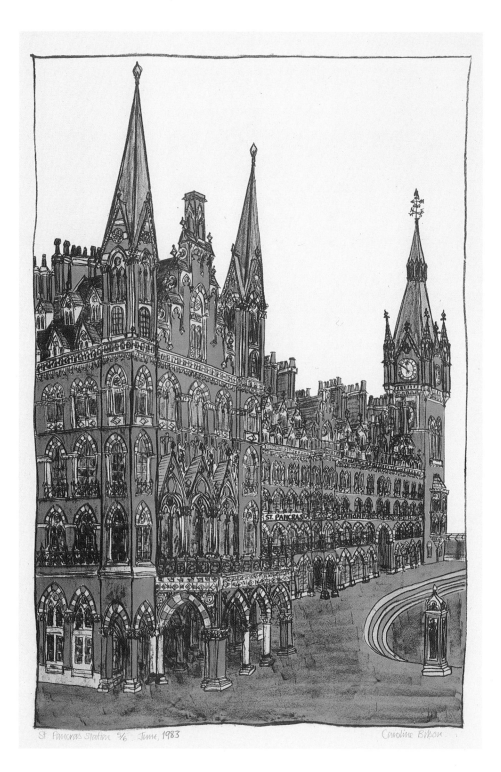

St Pancras Station 5/6 June, 1983 Caroline Bilson

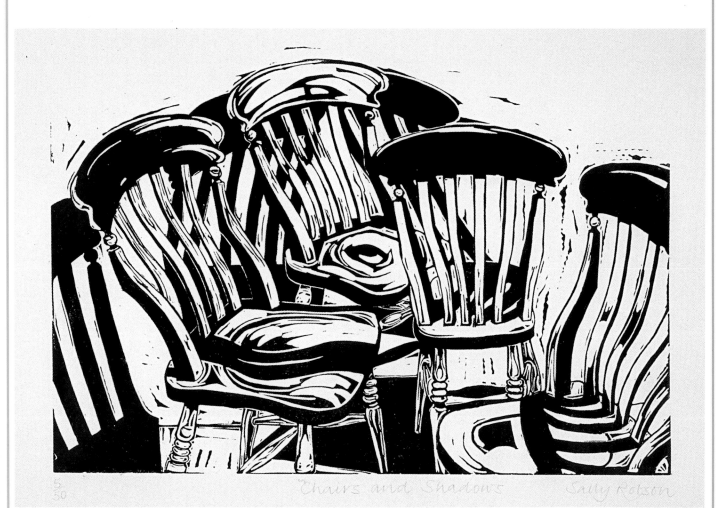

Chairs and Shadows Sally Robson

Sally Robson
Chairs and Shadows (linocut)
Relief printing techniques lend
themselves to strong
monochrome imagery,
interpreting the subject as a
bold pattern of light and shade,
often anchored, as here, by a
firm, rhythmic line. The balance
of this image comes from the
varying directional forces of the
lines, and the powerful graphic
contrast of solid black and
white shapes. The curving
design draws attention to the
more complex detail at the
centre of the image, where the
positive shapes are
counteracted by the heavy cast
shadows.
● Linocut: cutting the block,
page 30

▶ **David Carr**
Jerusalem (etching)
The tonal weight of this image comes from detailed line work, where hatched and crosshatched lines drawn in hard ground have been used to develop dark masses and interlocking forms. This is contrasted with open areas of white crossed by more fragile, sketchy lines and random marks that increase the textural variation. A light aquatint gives delicate tone to the background landscape.

● Etching: drawing on the plate, pages 90–91; aquatint, pages 94–95

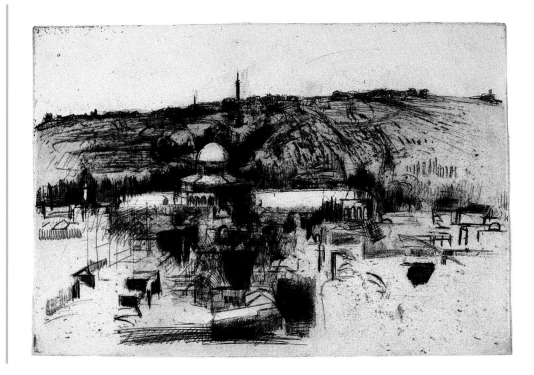

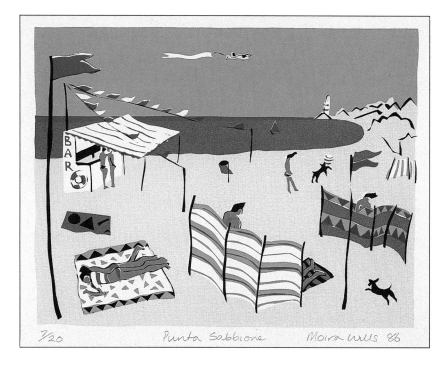

◀ **Moira Wills**
Punta Sabbione (screenprint)
Despite the solid colour areas, this screenprint is very linear in character, not only because of the fine lines cut for the black stencil. The narrow loop of the sea creates a strong directional curve, defined by colour changes rather than a visible outline. The colours contribute a well-chosen tonal balance to the image, at the same time creating a fresh, descriptive impression of the sunlit bay.

● Screenprinting: hand-cut stencils, pages 62–67

▶ **Trevor Price**
Cyclamen (etching)
This is an aquatint using a technique that imitates the effects of the mezzotint process. The aquatint was laid over the whole plate and etched in acid to produce a very dark tone. The greys and whites were then brought out by burnishing down the aquatint texture to different degrees. This process enables the artist to create very subtle gradations of tone, particularly visible here in the soft folds of the fabric. However, the subject has also suggested a linear element, interpreted as white lines on black, in the vein patterns of the cyclamen leaves.

● Etching: aquatint, pages 94–95
● Mezzotint, pages 80–83

GRAPHIC IMPACT

LINE AND SHAPE • EDGE QUALITIES • CONTRAST

A picture that has strong graphic impact draws your attention immediately. There are certain elements of style and composition that practically guarantee this kind of instant attraction – calligraphic line, bold shapes, hard edges, powerful tonal contrast, bright colour, repetitive pattern. All these are used to draw the eye to ephemeral graphic communications, such as posters and advertisements. The pitfall for the artist is that relying on these elements too simplistically can create an image that has impact but reveals all in the first viewing.

Ideally, a fine art print is something that can stand long or close acquaintance, so the initial impression contains additional subtleties to be discovered and appreciated.

What usually delivers this more lasting richness is a degree of variability, an unexpected touch. The relief printing media, especially woodcut and lino-cut, lend themselves to apparently simple, impactful approaches – clear-cut black-and-white images are typical of these processes, and naturally make strong graphics. They need to contain beautiful or disturbing shapes; controlled but fluid line work; distinct edge qualities; crackling textures. Making use of a medium's restrictions can sometimes be as effective as trying to extend its potential. The strictly practical advantages of monochrome block prints are that they are easy to produce and the materials are inexpensive.

The techniques of preparing and printing lithographs, screenprints and etchings invite you to conceive images with a more complex amount of layering or surface activity. Of these media, screenprinting is most likely to be associated with strikingly graphic imagery; certain stencil processes encourage this quality, and the process has been widely used for printing posters. Lithography, too, has a direct association with posters and illustrations; its graphic qualities can combine with or supersede its more painterly effects. Pictorial impact can come from dynamic composition or vibrant colour.

Etching is characteristically a more reticent and subtle medium, but because you can apply many different techniques to a single plate, all etchings have an underlying graphic unity that draws together the variations of line, tone, texture and colour. This makes an etched image all the more expressive, whether simple or complex.

◀ **Rebecca Owens**
Granada and 1850
(monoprint and linocut)
The bold graphic organization
of the building's façade is
defined by a cut lino block
printed over colour areas
previously monoprinted from an
uncut block. The artist also
added light watercolour
washes to knock back some of
the stark white lines around the
windows.

▲ **Carole Katchen**
Old Woman of the Andes
(woodcut)
The extreme contrast of black
and white creates its strongest
impact when the picture area is
divided into simple, powerful
shapes. Relief printing
techniques encourage a bold
approach to the balance of
dark and light, but the artist has
provided visual interest in the
background by working with

the wood grain to produce a
halftone effect. There is a clever
counterpoint in positive/
negative interchange between
the black lines mapping the old
woman's face and the white
lines on black describing the
folds of her wrap, enhanced by
sensitive line variation.

▼ Ian Mowforth

Dancing Figures (linocut)
Repetitive shapes create harmony and rhythm, but they are sufficiently varied to engage the viewer's attention in each section of the print, as well as making a lively overall design. The graphic black line forms the character of the image, nicely contrasted with more delicate textures and colours in the collaged papers underneath. The nine square blocks were cut separately, so could be assembled in any order for printing.

▲ Paul Smith

Angry Christ (etching)
Intaglio techniques have been established for centuries, but new refinements can be found. This etching was made on Solarplate, which eliminates the use of acid. A positive, opaque image is exposed onto the pre-sensitized plate in sunlight (or artificial UV light) and washed out with water, which "etches" the design. Here the artist has used the new technique to produce a striking icon-like interpretation of a traditional subject.

◀ Pip Carpenter
Red Rocks of Danger
(lithograph)
Lithography allows the artist to
create a striking, atmospheric
image with bold brushstrokes
and crayon drawing. The warm
colour range of the restricted
palette reduces contrast, but
the arrangement of tones
introduces depth and distance
without devaluing the strong
graphic pattern of the black
marks.
● Lithography: preparing the
plate, pages 113–117

Colin Paynton
Loons (wood engraving)
The dramatic curves and
rhythms of the overall
composition create immediate
impact, anchored by the solid
black shapes and clean white
lines. But the complex and
inventive variations of stippled
or hatched textures gradually
draw the eye into many subtle
layers of graphic detail.

► **Tiffany McNab**
Cheese Plant (etching)
Although the colouring of this etching is very subtle, the organization of shapes and balance of tone make it a particularly arresting image. The twisted stems and large leaves of the cheese plant draw the eye because they form a strong graphic pattern, emphasized by their dark colour. Those bold, rather stark shapes make an interesting contrast with the regular, solid objects in the foreground and their intricate pattern detail.

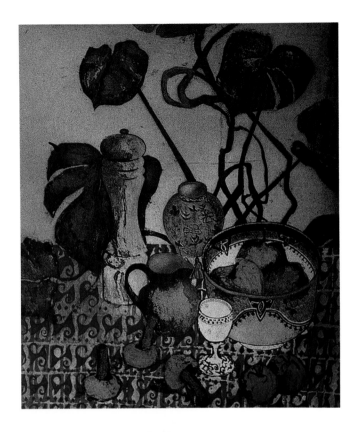

◄ **Jonathan Heale**
Catnaps Edition (woodcut)
A simple, everyday subject becomes an unusual, witty composition, when seen from an unexpected angle. By treating the human subject almost as a background element, the artist finds a strong combination of large and small shapes and makes the most of the bright patterning that frames the simple, elegant form of the cat. The print is a black-and-white woodcut hand-coloured with watercolour paint.

Paul Bartlett
Pretty Little Song Birds
(screenprint)
Rather than prepare separate images for each colour, the artist used one screen and added to the painted stencil after each printing, gradually reducing the open areas of the screen mesh – a process similar to the reduction method of relief printing. The variety of coarse and subtle textures gains impact from the organization of related colours and contrasting tones.
● Screenprinting: filler stencils, pages 70–73
● Woodcut: colour printing, pages 40–45

PATTERN AND TEXTURE

SURFACE VALUES • VARYING TONE AND TEXTURE • FORMAL PATTERNS

Many prints are executed in black and white or a restricted colour range, which in turn restricts your use of colour as a way of varying the surface qualities and making the shapes interactive. Certain media, particularly block prints, also preclude the subtleties of shading conventionally used to model form. Pattern and texture can perform both of these functions in a composition, so they are particularly important elements of printmaking.

Texture works in three distinct ways in prints; firstly, each medium has characteristic textural qualities to do with the materials and the kinds of marks that you can make on or with them – one of the most easily identifiable examples is the slight graininess typical of lithographs, because the litho plate itself has a definite grain; there is a similar effect in the aquatint process in etching. You can also use different techniques to create textures intended to match or stand in for specific textures in the subject; or you can exploit similar processes simply to make the surface of the print more interesting.

Pattern is not inherent in printmaking materials, but in some cases the patterns you can easily make are directly related to the tools. The V-tools and gouges used in linocut and woodcut lend themselves to broadly hatched lines – straight, curving or spiralled – and relatively coarse dot patterns or V-shaped, short cuts. A drypoint or etching needle is ideal for fine hatching and cross-hatching, and also delicate stippling. Wood-engraving tools have a lighter touch than gouges, but cut more broadly than intaglio needles. Discreet patterns of lines and dots are a way of creating shading and gentle gradations of tone, and have been used as such in prints and drawings for centuries.

There is a crossover between pattern and texture in purely visual terms. The texture of foliage, for example, might be simulated by making a rough pattern of aquatint tones. Sometimes it is the overall feeling for shape and structure in the image that creates an impression of patterning, whether or not individual shapes contain surface variation.

▶ **Elisabeth Harden**
Goldfish (lithograph)
The translucency and reflectiveness of the goldfish pool is conveyed by preparing the plate images with lightweight crayon drawing and washes of lithographic ink, then printing with semi-transparent layers of colour. The cool, neutral colour range works equally effectively in representing the water and the stone statue. Broad shading in warm yellow suggests the denser textures of flowers and foliage.

◀ **Roland Stringer**
Room 61 (wood engraving)
The delicate touch of the engraving tools gives great charm to printed textures in a small-scale wood engraving. Variations from coarse to fine marks in hatched or stippled areas transform black-and-white contrast into a full tonal range.

David Koster
Burnet Moth (lithograph)
There is a strong linear quality to this composition which creates both visual texture within the print and a sense of the natural textures in the subject. The artist draws in litho ink, using quill pens and brushes, to prepare the black plate, which forms the key design for additional colour plates. The printing inks are made very transparent, to gain the maximum effect from overprinting. This also emphasizes the grain and fragile edge qualities of the washes. Occasionally, the artist adds touches of strong colour by direct stencilling on to the finished print, where a small colour area does not justify processing of another plate.

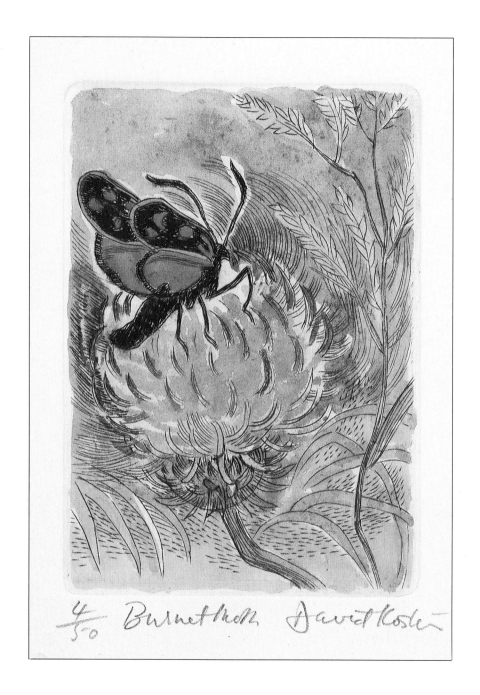

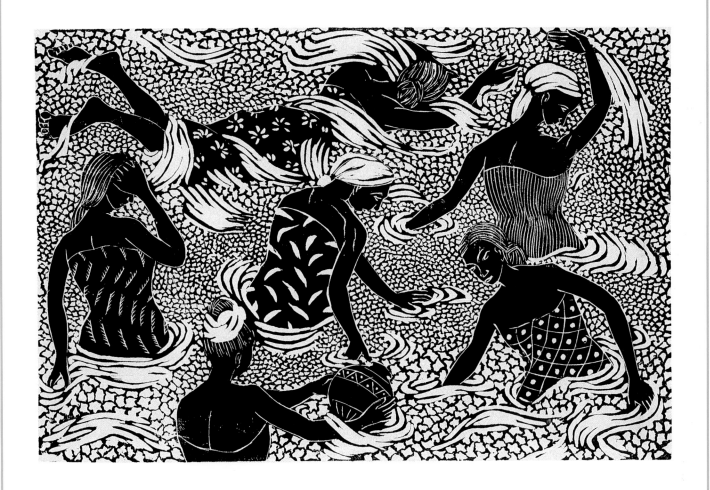

Richard Don Gabriel
Bathing Women (woodcut)
This image captures a lively sense of movement and interaction by concentrating each element of the subject into a formal pattern device. The balance of tones is beautifully organized by letting the white play a strong role in the mosaic and striped patterns representing the swirling water, while keeping the patterns of the women's clothing relatively dark so their bodies form graceful black silhouettes. On a close-grained wood block the cut shapes remain crisp and the ink prints with an even, dense texture.

Phil Greenwood
Meadow Clocks (etching)
In painting, the colour interest
of a landscape subject often
dominates, drawing attention to
the broad impression rather
than the intricate detail. But the
natural textures of grass,
foliage and flowers are ideal for
the scale and subtlety of
etching. The complex tracery of
linear drawing in the
foreground is sharpened by the
soft aquatint texture of the dark
trees, and this textural balance
is further developed by the
strong tonal pattern of the
image.
● Etching: drawing on the
plate, pages 90–91; aquatint,
pages 94–95

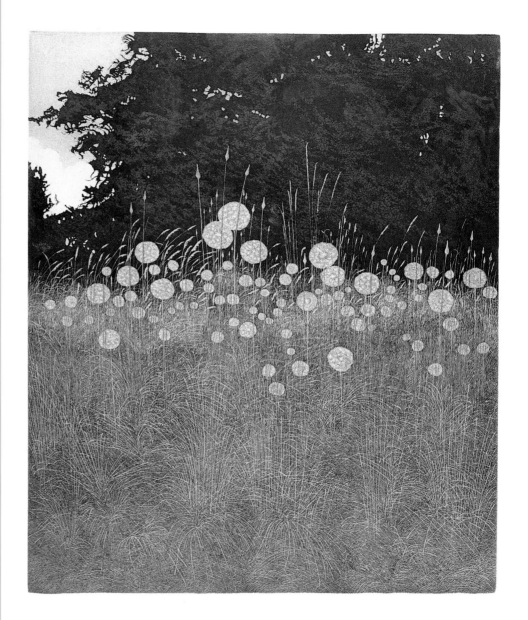

Paul Bartlett
The Empty Chair (etching)
The sugar-lift etching technique enabled the artist to make a detailed painting of the subject on zinc plate and reproduce the shapes positively. The plate had been coated with aquatint resin so the image would etch with subtle tonal variations and grainy texture. A striking, almost photographic, effect is achieved through the well-judged combination of meticulous, small-scale detail and boldly contrasted, broad areas of light and shadow.
● Etching: sugar-lift process, pages 98–99

Sonia Rollo
Ginger Jar and Anemones (etching)
In this charming still life the natural pattern effect of curving flower stems is briefly echoed by the sparser, painted pattern on the jar. The colours are printed from three plates, so that different colours and textures overlap. The soft forms of leaves and flower petals were formed by impressing marks in a waxy soft ground.

The gentle aquatinted colour gradations of the blue jar are created by the etching technique known as "spit-bite": rather than immersing the plate in acid, selected areas are dampened and a dilute acid solution dropped in. This allows controlled biting of soft-edged shapes.
● Etching: soft ground, pages 96–97

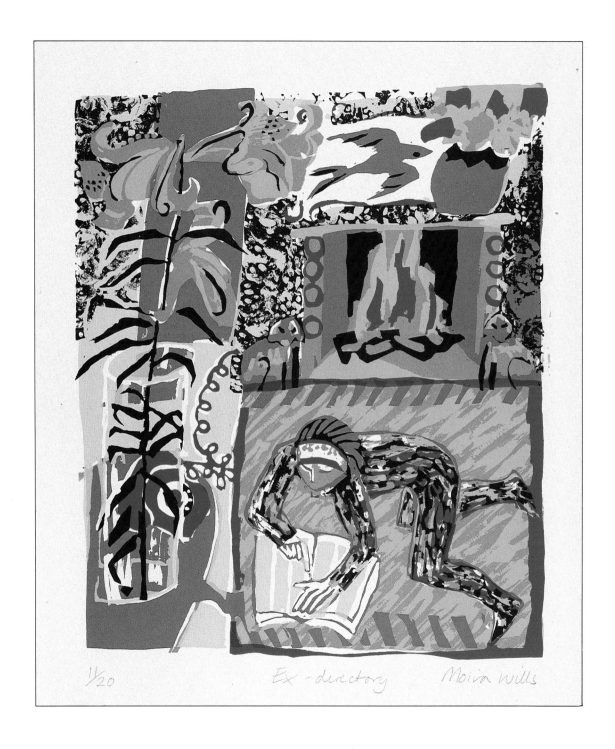

11/20 Ex - directory Moira Wills

◀ Moira Wills
Ex-directory (screenprint)
The print's all-over textures, bold patterns and brilliant colours match the vigour and spontaneity of a directly painted surface. Part of the fascination of the image is the way some shapes seem either to overlap randomly or not quite fit together, which adds to the energy. The hand-painted textures are active and occasionally unpredictable. It takes great confidence and discipline to achieve these effects so successfully in a print medium, where the final impact remains unknown until the last colour is printed.
● Screenprinting: filler stencils, pages 70–73

▶ Rebecca Owens
Japanese Fish (monoprint and linocut)
This print successfully integrates a limited selection of strong colours, using pattern to enliven the stylized, simplified shapes. Broad colour areas were put on paper by monoprinting, then the cut lino block was printed over them in red and dark green, using small rollers or a brush to apply the different colours to the block. The darker red in the fishes' patterning was applied by hand after printing.

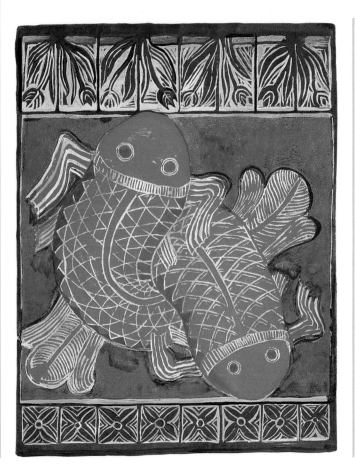

▲ John Elliot
River Scene (collage print)
An interesting combination of techniques has been used to produce this unusual, textured effect. The line work was printed from a zinc plate made by a commercial printer from the artist's original drawing. The broader impressions of tone and colour were overlaid from relief "blocks" of varying levels cut out of illustration board. Inking with soft oil pastel rather than printing inks provided the gentle, textural colour gradations.

COLOUR

ADDING COLOUR • THE PRINTMAKER'S PALETTE • DESCRIPTIVE AND EXPRESSIVE COLOUR

Colour plays a variety of roles in printmaking, one of which is to add a purely decorative element to images that were planned to work successfully in black and white. Two simple ways of imposing colour on a monochromatic design are hand-colouring with watercolour or gouache, or applying collage to the paper before or after printing. You maintain the advantage of being able to produce multiple, identical prints, but combined with the means of making each one an individual interpretation.

More frequently, colour is not just decorative but descriptive, relating directly to the colours of the subject; or expressive, conveying something about the artist's response to the subject and sometimes forming a characteristic element of personal style. Most of the printmaking media can easily accommodate multi-coloured images – any restriction is imposed not by the materials available, but by the effort you want to put into developing the image. Screenprinting, for example, has a potentially infinite colour range – you can pre-mix as on the painter's palette. But to combine many colours, even when mixtures are produced by overprinting, you have to repeat many times the physical labour of

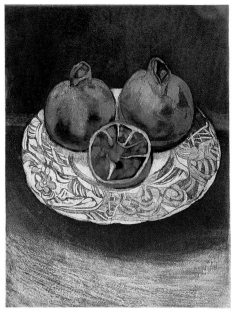

preparing stencils, pulling prints, registering colours and cleaning down the screen mesh.

It can be difficult to plan many successive colour layers, and the graphic qualities of a print may be lost if the colour relationships are too complex and busy. You need the confidence to predict how the colour combinations will appear after all the printing stages, and perhaps to adjust your expectations during processing. A limited palette is often the wisest choice because it is a controlled form of expression. Some artists enjoy printmaking precisely for this reason – they find working as imaginatively as possible with well-defined processing stages more sympathetic than the apparent freedom of direct painting techniques – which can leave the questions of how to start and when to stop too bewilderingly open-ended.

Colour in intaglio printing is often more limited, muted and subtle than in other media because of the inking and printing methods. Bright or strong hues may be introduced as local colour or to create a mood, while line and tone form the structure of the image. There is typically more emphasis on tonality than on colourfulness, but the effects can be very richly textured.

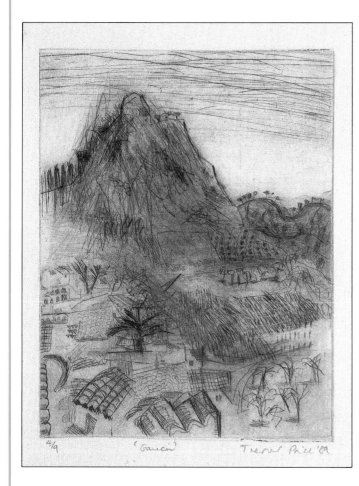

▼ Elisabeth Harden
Making Marmalade (lithograph)
Although lithography can provide a wide, painterly palette of tones and colours, a restricted colour range can be particularly effective because of the layering and textures that can be included in the image. In this print the colours are used as descriptive features of the subject, but also form a subtle, muted visual contrast, using the opposite orange/yellow and blue/purple sections of the colour spectrum.
● Lithography: printing, pages 119–123

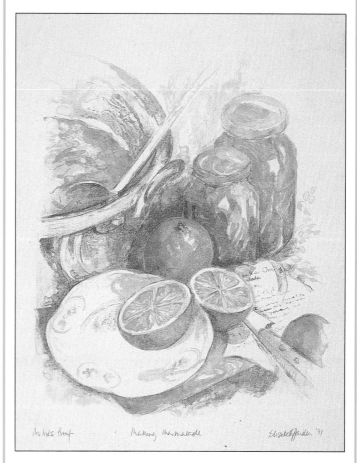

◄ Pip Carpenter
Three Pomegranates (etching)
A rich, descriptive colour effect has been achieved by printing from two plates – one inked in blue, the other with gradations of crimson, red, orange and yellow. In the lower part of the picture the blue lines and aquatinting provide local colour and tone; in the fruits and background, blue creates a dark undertone for the warm colours.

▲ Trevor Price
Gaucin (drypoint)
Printed in four colours from four separate plates, this image shows each colour clearly and also soft mixtures where they merge and overlap. There is an intriguing interplay between the heavy tones where ink is retained in the scratched lines of the drypoint, and the faint drifts of colour picked up from the plate surface.
● Intaglio printing: colour printing, pages 108–109

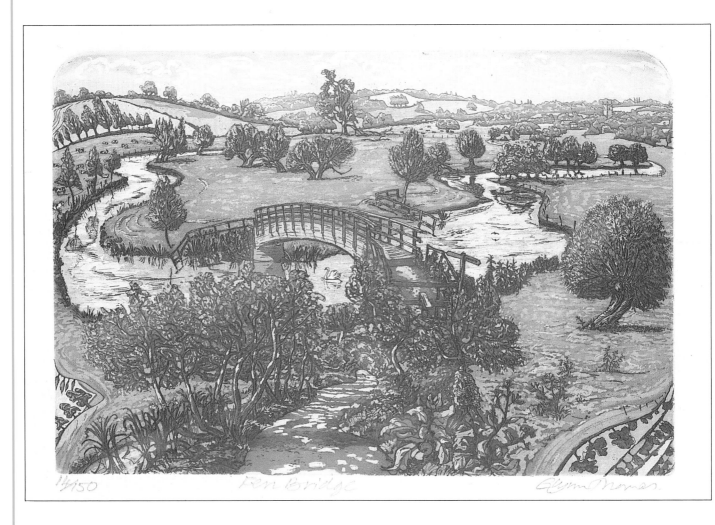

14/50 *Fen Bridge* Glynn Thomas

Glynn Thomas
Fen Bridge (etching)
Whereas other printmaking methods typically rely on overprinting to vary the colours, the simplest method for intaglio processes is to apply the required colours to different areas of the same plate, so the whole image is inked and printed in one sequence. This creates soft transitions from one colour to another, and the drawing qualities tend to play the strongest role in defining the subject. But in this etching the colours and tones describe the space of the landscape view and its patterns of light and shadow.

● Intaglio printing: colour printing, pages 108–109

▶ **Pip Carpenter**
Hyacinths (drypoint)
A subject which has a strong pattern of individual shapes as well as integral vivid hues can be equally effective interpreted in monochrome or colour. The potential for hand-colouring black-and-white prints leaves the artist free to make choices about the final presentation. Here the sensitive lines and rich blacks of the drypoint drawing are enhanced by vibrant watercolour washes built to varying strengths.

◀ **June Ann Sullivan**
Beach People (monoprint)
The image is prepared for printing using etching inks, with solvent to vary the textures. Where the ink is thickest, the colours are vivid and rich; together with broad white highlights where the paper is left bare, this creates the sunny mood of the picture. The foreground was added using transparent ink base with a touch of colour.

Rebecca Owens
Summer Fruits (monoprint and linocut)
This lush, naturalistic colour rendering was built up in three layers. Background colour and undertones were first applied as a monoprint. The cut lino block describing the shapes and textures of the fruits was then inked in several colours, using small rollers and brushes to apply water-based block printing inks, and overprinted on the first colour layer. Small touches intended to bring out the textural detail were added by hand, such as the opaque white highlights that put the final gloss on the cherries.

Edith Edwardson
Royal Naval College (etching)
Deeply bitten areas of the etching plate produce characteristic broad, grainy outlines, shadowy shapes and bold textures, giving depth to the frontal view of the architectural structure. The unusual colour combination contributes a good effect of tonal contrast, and the heavy mauve-pink cast over the whole image enhances the dramatic portrayal.
● Etching: etched textures, pages 100–101

Catherine Nicodemo
Seated Woman in her Dining Room (monoprint)
The melancholy mood of this image relates directly to the monochromatic palette. The yellow is a somewhat acid colour, more so where it blends into the greys and becomes greenish. The dynamic contrast of pure black and white shapes subtly exaggerates the interior space, in which the small figure is almost an incidental detail. The medium is heavily worked, moist, watercolour paint.

▲ Ian Mowforth
Mackerel (linocut)
The simple, graphic shape and patterning of the fish is provided by the lino block. The glittering colours of the fish skin come from a collage of various materials – silver leaf, coloured tissues and printed papers. These were assembled on thin textured paper, which was then laid over the inked block to print the linocut. Because the paper is translucent, it was possible to see through it clearly to register the collage correctly over the black line work on the block.
- Linocut: proofing and printing, pages 31–33

Diana Croft
Rainbow Trout (lithograph)
The particular qualities of each printmaking medium assist the artist's interpretation of a subject. The shiny, scaly texture of the fish is a strong feature in this still life, as in the linocut opposite. Lithographic techniques enable the artist to build up shimmering colour from delicate marks and textures – spattered ink and grainy crayon drawing. Red, yellow and blue are strong colours, but they are cleverly merged and muted here with descriptive effect.

◀ **Sally Robson**
Royal Hill, Greenwich (etching)
Even when an image is mainly dependent on effects of line and tone for its descriptive qualities, colour printing can add both visual interest and touches of local colour. In this attractively "stacked" composition depicting closely built streets full of architectural detail, the subtle, warm colours create a more inviting mood than hard black, without detracting from the intricacy of the graphic interpretation.

COMPOSITION

FRAMING THE IMAGE • BALANCE AND RHYTHM • DIVIDING THE PICTURE PLANE

A printed image frequently requires more careful preliminary organization than a drawing or painting that can evolve freely on the working surface. The composition must relate effectively to the scale and proportions of the base material on which the image is prepared – particularly on a block or plate because its edges usually show in the print. If part of the image is put down in the wrong place, or is out of proportion, it can be difficult to amend or erase it. If you are printing in more than one colour, you need to be able to locate the colours accurately in separate printings, to register finally as a unified image.

I'M HERE

You cannot tell exactly what you will see in a finished print until you print it, so many artists like to get a firm sense of composition through a working drawing or colour study before beginning to work within the print process. The initial study may be used only as a reference guide, or can be traced off to form the basis of the print.

The elements of composition in printmaking are no different from those in any other artists' medium. The overall picture needs some kind of rhythm or balance – this can be mainly created by lines or by solid shapes and masses, with stresses running vertically and horizontally across the picture plane, diagonally or randomly. The image can be centralized and contained, or strongly related to the edges of the outer "frame". The shapes can be presented flatly, modelled with colour and tone, or activated with patterns and textures. The spatial arrangement may be descriptive or formalized, recreating what is seen in the subject or interpreting your impression.

The variety of options you have depends both on the medium you are working in and the nature of your subject. None of the printmaking processes imposes absolute restrictions on the form of a composition, but you need to consider the character of your medium as you plan the image – the means of creating texture are, for example, less complex and subtle in linocut than in lithography. The pictures in this section are chosen to show how artists work inventively within the disciplines of their media, as well as demonstrating particular forms of pictorial organization.

I'm Here (screenprint)
The oval vignette is the dominant shape of this image, with the rectangular outer frame acting as a boundary to background colour. The shapes of the creatures are elegantly fitted to the oval, but allowed to break through its shape just enough to disrupt the symmetry. Screenprinting offers particularly effective techniques for achieving powerful hard-edged shapes and clearly defined colour areas.
● Screenprinting: hand-cut stencils, pages 62–67

Theresa Pateman
Spike of the Old Kent Road (linocut)
This witty linocut emphasizes the character of the dog by making him a massive, self-contained presence occupying more than half the picture area. This creates a very clean, strong division between the black and white shapes, although the strong linear detail conveys a sense of movement and interaction between different parts of the image.

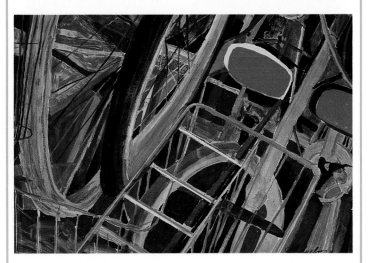

June Ann Sullivan
Bikework III (monoprint)
A close-up view creates a rhythmic, abstract composition, but with many still-recognizable features that give the shapes a context. The original was painted in gouache on acrylic sheet and printed off onto damp, heavy watercolour paper. This provides the contrast between dense, bright colours and more fluid, wash-like textures. In choosing a water-based medium to work with, gouache was preferred to watercolour because its colours remained stronger after drying.

▶ **Glynn Thomas**
Pin Mill Window (etching)
A frame within a frame is an interesting way of dividing the picture surface formally. In this case the window panes create a very balanced, regular division, but the view beyond the window fills each rectangle actively in a different way. The informal, curving and diagonal lines of the boats' riggings play against the fixed horizontal and vertical framing.

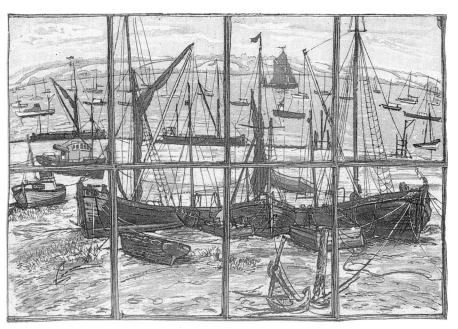

Artist's Proof Pin Mill Window Glynn Thomas

◀ **Judy Martin**
Cheetah after Prey (etching)
One way of conveying a
sequential element in the
subject matter is to develop a
series of images that can be
printed together as one. This
etching consists of three
separately prepared plates
assembled as a "triptych".
Because intaglio plates are
printed by direct contact and
the image is reversed onto the
paper, the plates had to be
positioned on the press in
reverse order to obtain the
correct sequence in the print.
● Intaglio printing,
pages 102–109

▶ **Susie Perring**
Trick Cyclist (etchIng)
The spotlit "cyclist" is the centre
of attention at the physical
centre of the rectangle on
which he is drawn. The shapes
are simplified but beautifully
suggestive of mood and
atmosphere, with active
textures in the black areas that
modify the harshness of such a
strong tonal contrast. The rich,
velvety marks were formed by
impressing a soft etching
ground.
● Etching: soft ground,
pages 96–97

◀ **Elisabeth Harden**
8 a.m. (lithograph)
In preparing lithographic plates
you have the same sensitivity of
touch as in drawing or painting
on paper. Crayon marks and
washes can be gently faded
out, to "lose" the edges of the
image and disturb the effect of
rectangular framing. It is
possible to organize the
balance of the composition so
that printing on white paper
makes the image appear as a
completely free shape or, as
here, loosely contained by a
conventional format.

Colin Paynton
Puffins (wood engraving)
The hard end-grain blocks used in wood engraving enable the artist to control fine cutting techniques that create intricate texture. The halftone effect of stippling and hatching is beautifully balanced with solid areas of black and white. Every shape contributes to the rhythmic flow of the composition, which is both accentuated and counterpointed by the changing emphasis of the rippling lines.
● Wood engraving: cutting the block, pages 50–51

1/50 Katchen 1980

Carole Katchen
Yoruba Man (etching)
The figure makes a beautiful, fluid shape placed boldly at the centre of the image area. An overly symmetrical sense of balance is avoided by the slant of his relaxed posture and the off-centre shape of the table leading out of the frame in the foreground, which together make a diagonal pull through the image. The contrast of tonal shading and plain against patterned areas is perfectly judged.

▶ **Trevor Price**

Tiffany in the Bath (etching)
In a domestic interior, a view from above is unusual and it introduces an element of abstraction. The clearly defined shapes divide the picture emphatically and isolate the pattern area on the right. The artist has also used the three-colour printing to create spatial organization and modelling. The figure is described quite naturalistically, and a good pictorial solution has been found for the depth and movement of the bath water – by scraping back a dark-toned aquatint to retrieve pale tones. Some of the ripple pattern was also made by drawing in line through hard ground.
● Etching: applying hard ground, pages 88–89; drawing on the plate, pages 90–91; aquatint, pages 94–95; Intaglio Printing: colour printing, pages 108–109

▼ **Sonia Rollo**

Checkmate (etching)
The checkerboard forms a regular grid on which the creatures are placed symmetrically, creating a mirror-image effect. The strong geometric balance works because the contrasts of light and dark tone, and of regular and organic shapes, provide visual interest across the whole surface.

Peter Strachan
Normandy Beach (screenprint)
The sky is often a significant
feature of an outdoor view, but
a very bold decision has been
made here in allowing it to
dominate the picture so
dramatically. The intensity of
the heavy, flat blue is offset by
the vivid handling of light
striking the white buildings on
the beach. This artist typically
uses hand-painted and
sometimes cut-paper stencils
combined with photographic
imagery. Special facilities are
required to prepare photo-
stencils and expose them on
the screen; photo techniques
can also be applied to etching
and litho plates.
● Screenprinting: hand-cut
stencils, pages 62–67; filler
stencils, pages 70–73

MOOD AND ATMOSPHERE

TONE AND COLOUR • QUALITIES OF LIGHT • CREATING SPACE

Certain subjects are attractive because they convey a particular mood or sense of place which becomes an important factor in the artist's interpretation. Often this is best conveyed not by making a literal description of the subject, but by enhancing some quality within it that conveys the impression of mood and atmosphere.

Local colours – the colours that things really are – may be much modified by atmospheric effects or the pattern of light, especially in open landscape or in a shadowy interior. The typically restricted palette of a colour print can be surprisingly effective in rendering these visual sensations. The artist can avoid distracting detail and focus on essential qualities of space, form and light. This may mean organizing the variations of colour, tone and texture more rigorously than in a painting, where individual brushstrokes can deal with fleeting and subtle transitions. An image prepared for print must achieve a similar impact by more economical means.

The atmospherics of light are perhaps easiest to handle when there are distinct contrasts of light and shadow, especially in a medium that encourages

strong monochromatic interpretation, like etching or wood engraving. Dramatic contrast is interesting, and needs careful management to achieve a coherent image without flattening the drama. Making light and space with colour is a definite challenge, particularly where the image has a fairly balanced, even key in the light or mid-tonal range. Close relationships of hue and tone convey space and mood by subtle interactions – the detail and texture of the image play a significant role. A highly detailed drawing brings the viewer into the subject, whereas dissolving forms and contours open out the pictorial space.

Whatever your medium, the balance of tone and colour is not immediately visible on the plate, block or screen that you are working with. With experience, you learn more about the way the marks you make will translate into print, but the proofing stage of any print is always an exciting moment, when you see your idea take shape. The marks and the colours often remain open to adjustment until the final stages, enabling you to achieve images that are both precisely controlled and highly expressive, like the examples shown here.

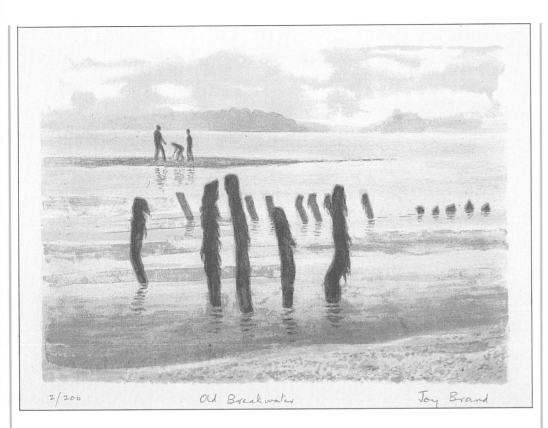

2/200 Old Breakwater Joy Brand

Joy Brand

Old Breakwater (lithograph)
The gentle tones and textures that can be achieved with lithographic painting techniques enable the artist to produce a very delicate and subtle effect of light on water. The rendering is sparing of detail and effectively employs the limited palette to develop the spacious, atmospheric feeling of the view.
● Lithography: preparing the plate, pages 113–117; printing, pages 119–123

◀ **Donald Wilkinson**
Summer Window (etching)
Conventionally, etchings often begin with line work in hard ground and then progress to incorporating tone and texture, using the line drawing as a guide. This print, however, creates a gentle mood by eliminating hard lines and edges, using soft ground and aquatint techniques to achieve subtle shadings and ghostly forms. The tonal range provides a sense of space and modelling, but with low-key contrasts of tone and colour.
● Etching: soft ground, pages 96–97; aquatint, pages 94–95

D. J. Carr

Captain Cook's Monument (etching)
This dramatic, silhouetted landscape view is darkly atmospheric, due to the tonal range and the varied marks of different etching techniques. The image was traced full size from a drawing and the main lines transferred to a plate coated with soft ground. The grainy line work so produced was developed with further drawing into hard ground, then the dark tone was applied with aquatint and the lights broadly "painted" by burnishing down the aquatint texture.
● Etching: drawing on the plate, pages 90–91; soft ground, pages 96–97, aquatint, pages 94–95

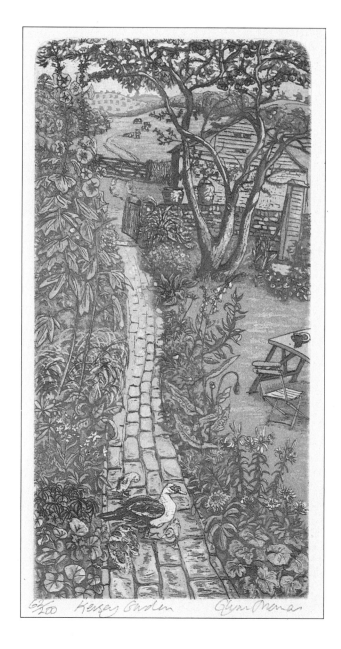

Donald Harris
Flurry (etching)
Rich, flat aquatint tones provide an atmospheric background to the whirling pattern of the birds and rippling water. The depth and mood of the image is enhanced by the colour gradations and occasional strong contrasts. Two plates were overprinted to obtain this range, one inked in blues passing from turquoise to violet, the other in yellow, orange and red.
● Intaglio printing: colour printing, pages 108–109

▶ **Glynn Thomas**
Kersey Garden (etching)
The yellow-green predominant in this charming composition gives a sunny, bright tone to the image, with the contrast of brown and dark green contributing space and depth. These colours were inked all together on the plate and printed in one: the brilliant red and yellow touches in the flowers were painted on the cleaned plate and overprinted.
● Intaglio printing: colour printing, pages 108–109

Moira Wills
Papillon (screenprint)
Using mid- to light-toned colours and an informal pattern of freely drawn shapes, the artist creates a bright, painterly image with much attractive detail and incident. It combines the small-scale fascination of plants and insects with the airy quality of open landscape and sky, without explicitly describing a particular location. The textures and edge qualities are cleverly varied by using a combination of stencil techniques.
● Screenprinting: hand-cut stencils, pages 62–67; filler stencils, pages 70–73

STYLE AND CONTENT

NARRATIVE • STYLISTIC INTERPRETATION • FORMALIZED IMAGES

Relief and intaglio printing have a long association with the traditions of graphic communication – woodcuts, for example, were one of the earliest forms of book illustration. These media readily lend themselves to subjects which seem to illustrate a storyline or contain a narrative of their own, in simple, direct images that "speak" to the viewer. Such subjects can be found in literary sources, in the incidents of everyday life or in special events, representing particular or universal themes. Also in keeping with the narrative element, an artist may produce a series or suite of prints on one theme; the scale and detail of printed images provide suitable means of "publishing" information, commentary and observation.

Apart from describing related events and images, a series of prints can also be unified by a distinctive style of imagery. There is a natural two-way stylistic development in the work of printmakers, who may choose a specific medium for its characteristic visual qualities, but also find that the techniques feed back ideas for appropriate forms of representation. The highly graphic qualities of prints, such as those described on pages 132–137, can encourage elements of personal style to become more strictly formalized than they usually appear within the looser disciplines of drawing and painting. For professional artists, a strong personal style is useful commercially; and they present themselves with the creative challenge of working out how that style can effectively interpret different elements of a theme, or widely differing subjects.

Printmaking techniques are an interesting area for artists working in a more abstract mode, in that the physical surface qualities of an image are specially important where the subject matter is less immediately accessible to the viewer. In this context, also, strong graphic qualities are worth exploration, the materials and methods of the craft offering unique forms of interpretation that might not occur using other media and processes. But although abstraction tends to focus the viewer's attention on formal and expressive elements of composition, rather than recognizable forms, these purely visual properties are just as essential to the success of representational imagery, as can be seen throughout this gallery of prints.

◀ **Mychael Barratt**
Animal Magic (etching)
The variety of surface effects achieved with the etching processes provides a full "vocabulary" of descriptive elements for figurative imagery. Soft ground and aquatint contribute rich, deep tones to the characterful drawing in this image, which is also hand-coloured to enhance the strong graphic effect and highlight the main subjects.
● Etching: soft ground, pages 96–97; aquatint, pages 94–95

▲ **Elisabeth Harden**
South Downs Way (etching)
This picture tells a story in charming, cartoon-like style, relying on the economy and sensitivity of etched lines. It is full of incident, and the composition is cleverly organized to lead the eye through the image, taking in each event and the characters involved.
● Etching: drawing on the plate, pages 90–91

Carole Katchen
Daily News (etching)
The everyday occurrence makes a memorable image when the artist is alert to both the narrative and pictorial qualities. The postures of these Nigerian women precisely explain how absorbed they are in the gossip of the day. The figures are isolated in the foreground, but given a context with the formal pattern of background silhouettes. The tonal contrast is strongly emphasized, but both dark and light areas contain much subtle, active texture.

167

Kazumasa Nagai
I'm Here (screenprint)
This is one of a series of prints with a strong conservationist message (see also page 154), using the same basic structure to anchor the stylized representations of the creatures, which take on a powerful symbolic presence. The shapes, colours and patterns are interpreted in a way that gives immediate graphic impact, each colour printed from a separate screen to maintain the clarity of clean, flat shapes.

I'M HERE

Save Being and Save World

▶ Caroline Bilson
Brighton (linocut)
The recognizable architectural features simplified into striking patterns of black and white are strongly representative of this artist's style and express a sense of place without going into a literal description. Relief printing media are ideal for this kind of bold, dynamic image, combining crisp contrast with rough, aggressive texture.
● Linocut: cutting the block, (pages 30–31

▲ Paul Bartlett
After Vincent (linocut)
There is a long tradition of artists learning from or paying homage to past masters by reinterpreting their style and imagery. In this linocut, the direct, graphic qualities are effectively employed to parallel the heavy, swirling brushwork of van Gogh's famous painting. It is printed from one block by the reduction method used for both lino and woodcut prints, re-cutting the design after printing each colour. The ink has been rolled on thickly and overprinting produces some interesting areas of broken colour.
● Woodcut: colour printing, pages 40–45

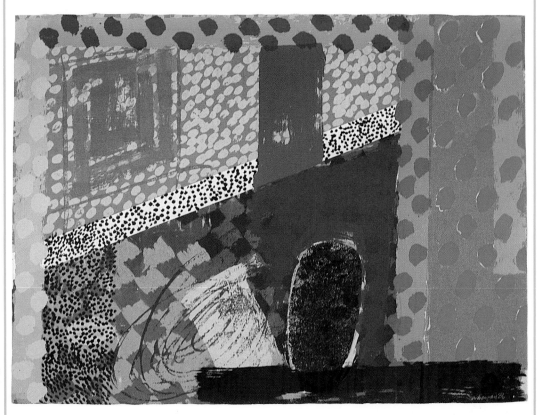

◀ **Kristian Krokfors**
Roadside (screenprint)
The purely visual sensations of colour play a dominant role in making an abstract image work. The colour interactions are often complex and exact, which needs careful forethought when the printmaking process is planned. Although this interesting map-like composition has a harmonious, limited colour scheme, it involved 15 separate screens, prepared with hand-cut, drawn and painted stencils, to achieve the required variations of colour and texture.

Sara Hayward
Purple Door (screenprinting)
This print is based on an interior scene but uses shapes and colours abstractly to explore their emotive qualities and the moods created by colour interactions. The screen stencils were prepared by drawing and painting with litho crayon and tusche, blocked in with gum arabic and then washed out, so the applied marks print positively. The inks were mixed in different ways to achieve a contrast of translucent and opaque colours, in a palette selected to convey the personalized, expressive elements of the artist's interpretation.
● Screenprinting: tusche method, pages 74–75

INDEX

ACKNOWLEDGEMENTS

Quarto would like to thank the following for all their help with this project:

The Print Gallery; CCA Galleries; and John and Shelia Elliot in the USA who researched many of the American examples in this book.

Tools and equipment featured throughout were kindly lent by T.N. Lawrence and Son (London and Sussex); L. Cornelissen and Son Ltd (London); George Hall (Sales) Ltd (London).

The following artists helped with the step-by-step sequences in the techniques section:
monoprint: Moira Wills, Judy Martin; linocut: Ian Mowforth, Moira Wills; woodcut: Caroline Bilson; wood engraving: Roland Stringer; collage prints: Judy Martin; screenprinting: Moira Wills; drypoint: Judy Martin; etching: Elisabeth Harden; lithography: Elisabeth Harden.

p10 Elisabeth Harden; p11 Moira Wills; p12 Collage print: Judy Martin; Etching: Elisabeth Harden; Wood engraving: Roland Stringer; Mezzotint: Phillip Coombs; Monoprint: Judy Martin; p13 Woodcut: Caroline Bilson; Drypoint: Juliet Kac; Lithography: Elisabeth Harden; Linocut: Ian Mowforth; Screenprint: Moira Wills; p83 Phillip Coombs; p109 top Phillip Coombs; p109 bottom Judy Martin; p126 Carole Katchen; p127 Anita Klein/Greenwich Printmakers; p128 Caroline Bilson; p129 Sally Robson/Greenwich Printmakers; p130 top David Carr; p130 bottom Moira Wills; p131 Trevor Price; p132 Rebecca Owens; p133 Carole Katchen; p134 left Ian Mowforth; p134 right Paul Francis Smith; p135 top Colin Paynton/Wildlife Art Agency; p135 bottom Pip Carpenter/Greenwich Printmakers; p136 top Tiffany McNab/Greenwich Printmakers; p136 bottom Jonathan Heale; p137 Paul Bartlett; p138 Roland Stringer; p139 Elisabeth Harden; p140 David Koster/Wildlife Art Agency; p141 Richard Don Gabriel; p142 Phil Greenwood/CCA Galleries; p143 left Paul Bartlett; p143 right Sonia Rollo/Greenwich Printmakers; p144 Moira Wills; p145 top John Elliot; p145 bottom Rebecca Owens; p146 Pip Carpenter/Greenwich Printmakers; p147 left Trevor Price; p147 right Elisabeth Harden; p148 Glynn Thomas; p149 top Pip Carpenter/ Greenwich Printmakers; p149 bottom June Ann Sullivan; p150 Rebecca Owens; p151 top Edith Edwardson/Greenwich Printmakers; p151 bottom Catherine Nicodemo; p152 top Ian Mowforth; p152 bottom Sally Robson/Greenwich Printmakers; p153 Diana Croft/Greenwich Printmakers; p154 Kazumasa Nagai; p155 top Theresa Pateman/Greenwich Printmakers; p155 bottom June Ann Sullivan; p156 top Judy Martin; p156 bottom Glynn Thomas; p157 top Susie Perring/Greenwich Printmakers; p157 bottom Elisabeth Harden; p158 Colin Paynton/Wildlife Art Agency; p159 Carole Katchen; p160 top Trevor Price; p160 bottom Sonia Rollo/Greenwich Printmakers; p161 Peter Strachan/Greenwich Printmakers; p162 Donald Wilkinson/CCA Galleries; p163 top Joy Brand/CCA Galleries; p163 bottom David Carr; p164 left Don'ald Harris/Greenwich Printmakers; p164 right Glynn Thomas; p165 Moira Wills; p166 Mychael Barratt; p167 left Elisabeth Harden; p167 right Carole Katchen; p168 Kazumasa Nagai; p169 top Paul Bartlett; p169 bottom Caroline Bilson; p170 Kristian Krokfors/Pratt Contemporary Art; p171 Sara Hayward.

Jacket images kindly supplied by Paul Bartlett, Mychael Barratt, Elisabeth Harden, Glynn Thomas, Moira Wills.